Gay & Gifty
Pot Holders

Barbara E. Mauzy

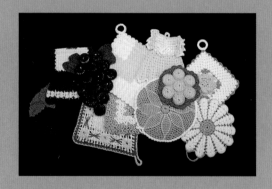

Schiffer® Publishing Ltd

4880 Lower Valley Road, Atglen, PA 19310 USA

$\mathcal{D}edication$

It is my deepest wish that when people think of color the only consideration is for the rainbow of hues shown on these pages. This book is lovingly dedicated to our very first grandchild, Kendyl Simone Jenkins. For you, Kendyl, Grandma (and Grandpa, too) offers this book with hugs and kisses!

Designed by Bruce M. Waters
Type set in Ribbon BT heading font/text font Korinna BT

ISBN: 0-7643-1686-9
Printed in China

1 2 3 4

Published by Schiffer Publishing Ltd.
4880 Lower Valley Road
Atglen, PA 19310
Phone: (610) 593-1777; Fax: (610) 593-2002
E-mail: Schifferbk@aol.com
Please visit our web site catalog at
www.schifferbooks.com
We are always looking for people to write books on new and related subjects. If you have an idea for a book please contact us at the above address.

This book may be purchased from the publisher.
Include $3.95 for shipping.
Please try your bookstore first.
You may write for a free catalog.

In Europe, Schiffer books are distributed by
Bushwood Books
6 Marksbury Ave.
Kew Gardens
Surrey TW9 4JF England
Phone: 44 (0) 20 8392-8585; Fax: 44 (0) 20 8392-9876
E-mail: Bushwd@aol.com
Free postage in the U.K., Europe; air mail at cost.

Contents

Introduction

An Historical Perspective

Many aspects of vintage kitchens and what we now collect from them is a reflection of historical influences. "Hoosier" cabinets were developed in the early 1900s because Mother needed a place to store and prepare home baking. Once commercially prepared baked goods became products routinely purchased rather than created with homegrown labors, the significant role of these cabinets diminished. This is one example of how changes in American kitchens are specifically dependant on time and money as these relate to sociological changes and historical impacts.

At the beginning of the twentieth century women were homemakers spending much of the day occupied with kitchen related tasks whether it be canning fruits, vegetables, and even meats, or creating anything from biscuits to noodles. The affluence of the 1920s led not only to the introduction of color in the kitchen but also to more frivolity. In 1927 Mother could have Mandarin red, apple green, or Delft blue kitchen accoutrements and in early 1929 her choices were expanded to include both wooden and Bakelite handles. For the first time American society acknowledged the kitchen as being more than simply a workroom delegated to food preparation and storage. With the addition of color the kitchen became another living space worthy of decorating.

After recovering from the Great Depression Americans again experienced a period of financial security. As an effort to reach into the pockets and pocket books of America, manufacturers proliferated a vast assortment of kitchenware in a variety of materials: Bakelite-handled utensils, tin accessories, wooden-handles gadgets and more. Mother had time and money, allowing a wonderful opportunity to accessorize her kitchen in colors that in 1937 included white, ivory, royal blue, kitchen green, delphinium blue, and red. Depression Glass, the colorful glass dinnerware often given free with the purchase of goods or services, was also at a peak in popularity at this time. Color abounded!

The outbreak of World War II and the resulting war effort created major changes in the family's attitude toward the kitchen that affected American households for the remainder of the twentieth century. First there was the use of specific materials. Metals needed for the production of weapons and their delivery systems were no longer available for domestic uses. Examples of kitchen products that were directly impacted by these shortages include porcelain for table tops and metal for kitchen canisters, trash cans, and the like. The manpower recruited to fight the war left households with reduced incomes. With limited funds, only necessities were afforded, and sometimes these with great difficulty. Finally, women entered the work force in earnest. Prior to World War II women, and often these were unmarried women, had been employed in domestic capacities, as teachers and nurses, and in secretarial positions. Now women were needed to operate machinery in

factories and with enthusiasm they rose to the occasion. It is important to note that at the termination of World War II many women retained their employment status resulting in the greatest impact of all to kitchenware, kitchen décor, and kitchen design.

Postwar America's affluence meant families could build new "modern" homes. These residences included features never before seen in kitchens: washers, dryers, small appliances, counter tops, built-in cabinets, and more. The additional conveniences were necessary to ease Mother's domestic responsibilities as she was working outside the home while continuing to maintain a household. Things we today take for granted were developed in the late 1940s to assist in streamlining a working woman's efforts. One example is the use of placemats. Prior to the late 1940s, draping a tablecloth was the first step in setting the table. After dining, the tablecloth needed to be washed and pressed regardless of how minute the soiling. When using placemats only those dirtied require laundering thus greatly reducing the labors involved in keeping the table presentable.

The concept of women working outside the home is no longer a phenomena. Manufacturers of house wares realized women's hectic schedules balancing work and home, motherhood and career could be improved through the use of labor saving devises. In the process of simplifying household demands many of the tasks completed by mothers of the early 1900s are no longer necessary. Women do not have to bake; they can choose to buy pastries and breads or bake, as they so desire. Women do not have to boil water and hand plunge the laundry, as almost every fabric manufactured today is designed to tolerate a washing machine. Most women would applaud these changes as improvements. However, the other part of this story is that much of what was done by our mothers, grandmothers, and even great-grandmothers has been lost. How many of us are able to can vegetables?

The transitions of the previous century are directly responsible for the popularity of kitchen collectibles. Not only do we seek to own that with which we have pleasant memories, but we also decorate with a sense of eras long past, seeking a simplicity we can attempt to recapture through the use of color and texture that is influenced by the heart.

Pot Holders Emerge

For generations women were making magic with needles. From sewing to tatting to doily-making, creativity plus time netted works that have become treasures passed from one generation to the next. Sewing, knitting, and crocheting transformed scraps of fabric and single strands of yarn or thread into usable household items whose artistry is only now receiving the recognition it's due.

By the 1900s most women were reusing or buying fabrics, yarns, and thread; the days of spinning and weaving as preliminary steps to creating soft goods were past. As household chores were simplified or even eliminated, time became available for other duties and tasks. The earliest book that I could find devoted exclusively to creating pot holders is from 1941. Placed within the context of the evolution of American kitchens, this makes a great deal of sense. Color was then a significant influence in the decoration of this

important room and pot holders added a burst of color when hung on the wall. Being pre-war, women were predominantly working exclusively in the home and modern advancements eased the burdens of homemaking. There was money to spend, time to occupy, and a need: "Since the way to a man's heart is through his tummy, rescuing hot pots and pans from the fire is woman's lot! Save your fingers and thumbs from nasty burns by using these crocheted pot holders that manage to be saucy while in the thick of things." (*Pot Holders to the Rescue*, c. 1941, The Spool Cotton Company) Keep in mind, 1941 is before television; families sat together in the evening listening to radio and mother could crochet a pot holder while enjoying the entertainment.

The need for pot holders existed, but companies that manufactured thread began a real campaign to make pot holders a part of every American home. "How about a Pot Holder Booth the next time your church or club wants to raise money? These bits of important accessories are useful, easy to make, at a penny-pinching price!" (*Pot Holders to the Rescue*, c. 1941, The Spool Cotton Company) *Pot Holders to the Rescue* included whimsical pot holder designs bearing clever names such as "Square Dance" (obviously a square pot holder), "Fish Story" (fish-shaped), "Three Little Maids" (faces embroidered on round pot holders), "Country Tea" (dark pot holder with a light-colored teapot motif crocheted into the design), "Popcorn" (textured crochet stitches created a popcorn-like triple border), "Frying Pans" (8" cords of rug yarn were twisted and sewn together to make round pot holders look like frying pans while providing a clever way to hang them), "Clock" (the face

of a clock is embroidered on a round pot holder), and so on. This one book provided directions for round-, square-, oval-, heart-, and animal-shaped pot holders, and more. New to crocheting? The five basic stitches were explained and illustrated. In a hurry? Two balls of rug yarn were sufficient enough to create five pot holders. Of course, all the threads and yarns listed in the "Materials" section were those created by the company sponsoring the book, which sold in 1941 for ten cents.

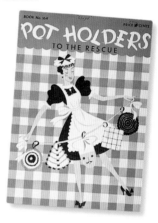

In 1943 The Spool Cotton Company extolled, "Kitchen is king of your household these days. Pot Holders are mighty important—why not make them gay conversation pieces?" (*Pot Holders*, c. 1943 The Spool Cotton Company) Designs with greater detail and more realistic shapes were expanded to include tea cups, flower pots, butterflies, mitts, kittens, strawberries, and more. Faces were now crocheted with black floss as Black Americana was gaining popularity as a decorative kitchen theme. Some pot holders were even made with two sewn together back to back with flannel or muslin padding in the middle. Stitch directions are no longer included in this 1943 book as it is assumed that the reader, being a modern homemaker, already knows how to crochet.

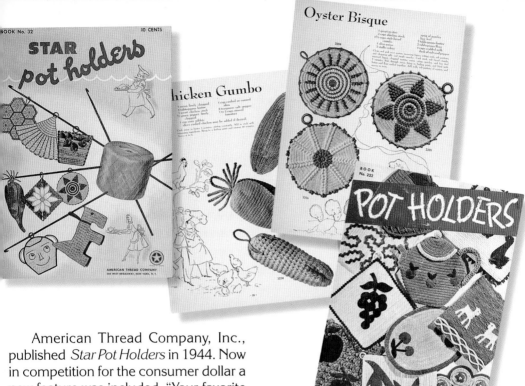

American Thread Company, Inc., published *Star Pot Holders* in 1944. Now in competition for the consumer dollar a new feature was included. "Your favorite dish…Your favorite potholder/Over 30 perky potholders designed in our Studio under the supervision of Cecilia Vanek with Star Brand Threads, and 12 tasty recipes to spice your culinary duties." (*Star Pot Holders*, c. 1944 American Thread Co., Inc.) This book is really a recipe booklet—Scotch Scones, Oyster Bisque, Barbecued Spare Ribs, and more-with large black and white images of pot holders throughout. The page providing directions for "Dogs á La" (hot dogs–not my Moxie) have two dog- and one cat-shaped hot pad pictured. "Eggs Foo Young" includes two hot pads with embroidered Asian faces. "Chicken Gumbo" is enhanced with vegetable-shaped pot holders: cucumber, carrot, and corn. Although many of the recipes do not directly relate to the pictured crocheted creations, there is a plethora of creative shapes and motifs and the first example of using a fabric appliqué on a pot holder.

World War II ended and a spirit of optimism transformed America. Appliqués became an integral part of the 1945 designs shown in **Pot Holders** (The Spool Cotton Company, c. 1945), as an even greater sense of whimsy led to pot holders having a sense of fun about them. A square pot holder was shown having white felt lambs, an apple-shaped pot holder had green felt leaves and a green felt stem, a black felt spade and club and a red felt diamond and heart were added to four square pot holders that were held on an angle to become diamonds. This is a particularly significant design as families were again united and card parties were developing into a significant part of the social scheme. Many of the pot holders shown in this book would be made using larger

7

hooks and heavier threads resulting in bigger stitches and a reduced production time. Remember, in many cases the homemaker had chosen to keep her fulltime job, and for the first time in modern women's history the pressure to perform at home and in the workplace was very real.

New Table Designs (The American Thread Company, c. 1946) is the first book to show crocheted placemats, a new concept as suggested by the title. The directions provided intricately detailed designs as well as simple ones created with heavy threads and large hooks showing sensitivity to the working women's time dilemma. No pot holder directions are given in this book.

American Thread Company published a second book of recipes and pot holders in 1947. Cecilia Vanek was the designer of *Star Pot Holders* which featured recipes for "crab meat au gratin" with a fish-shaped pot holder and a square pot holder having a crocheted crab appliqué, "honey date sticks" with bumble bee and butterfly pot holders, "spiced fruit compote" with apple, strawberry, and pear appliqués on round pot holders, and "maple sugar graham crackers" with a maple leaf pot holder. This is also the earliest book to show pot holders shaped as dresses and panties, favorites among today's collectors.

The late 1940s and early 1950s saw the growth in popularity of serving guests in buffet style. An interesting use of pot holder dresses at the buffet table is featured in *Quick Tricks in Crochet* (The Spool Cotton Company, c. 1950) and was named, "Salad Set Pot Holder." A wooden fork and wooden spoon were necessary to serve salad and this imaginative idea was designed to delight one's guests. The wooden spoon was inserted through the neck of the dress allowing the bowl of the spoon to become a "head." A wooden fork became "arms" after it was slipped through the two arm holes. Once again, whimsy and color enhanced the table! This 1950 book had a floral theme throughout most of the designs, and these are now among the ones most often seen and collected today. Perhaps because the book extols the virtues of creating sets there were more of these designs made. Perhaps being just a few less years in age more of them survived. For whatever reason, floral designs are easy to find and very, very popular. Even the "Salad Set Pot Holder" dress had five blossoms crocheted and then applied to the skirt. Crocheted flowers became so popular they were shown on slippers, handbags, and even on hangers and curtain tie-backs.

Crocheted matching kitchen sets were first shown in 1950. *Quick Tricks in Crochet* provided directions for: a "Round Hot Plate Mat" that was slipped over an asbestos mat, a "Pot Holder," often with a true front and less detailed back, a "Napkin Holder" made from crocheted pieces laced to a wire napkin holder, and a "Platter Mat," which was two enlarged Hot Plate Mats worked together into one piece without an asbestos mat.

Lily Mills Company published the first edition of *Crocheted & Knitted Kitchen*

Craft in 1950. Pot holders included "Cherry Whirl," (round with appliquéd cherries) "Pine Cone," (supposedly shaped like a pine cone, but this requires some imagination) "Corn Cob,"(made from rug yarn and shaped like corn on the cob) and "Kettle Black" (a caldron complete with two feet and a handle). Relatively new to the pot holder design world, directions for stitches are provided just in case the user was also new to this art form. Also included in this fairly comprehensive book are directions for a crocheted Napkin Holder Cover (floral!) and a Dahlia Hot Plate Mat. Cognizant of the popularity of flowers, explained and pictured in this book is a "Petunia" Tea Cozy.

Not to be outdone by the competition, American Thread Company's *Hot Plate Mats*, also from 1950, featured a mix of Hot Plate Mats and one rose motif napkin holder. These mats, sometimes in realistic shapes of flowers, leaves, and more, were simply larger-sized pot holders that served to protect furniture when hot dishes were served. Keep in mind that the increasing use of buffet style dining made it necessary to have something buffering table tops from hot casseroles and other serving pieces.

Shown for the first time in *Quick Tricks in Crochet* (c.1950) are pot holders and mats created by crocheting around bone rings 3/4" in diameter. It took 65 rings to create a "Large Platter Mat," 39 rings to create a "Small Platter Mat," and 19 rings for each "Small Mat." Done largely with single crochet stitches, this design was easier to complete than it looked.

Kitchen applications for crocheting were becoming so numerous that pot holders rarely warranted their own instruction books. In fact, they were relegated to the final pages of *Gay and Gifty Crochet Ideas*. American Thread Company's 1951 book included pot holder-like doilies, Hot Plate Mats or Covers and even a Plant Holder that used two pot holder-like pieces sewn together to create a pocket. The Rose Pot Holder featured a floral rosette in the center and the Corn Pot Holder is among the most realistic of all corn designs.

Pot Holders For Kitchen Pick-Me-Ups (The Spool Cotton Company, c. 1952) is the most recent book devoted exclusively to Pot Holders that I was able to locate. Offered was the "pot holder-of-the-month." "Start a new fad among your friends for seasonal pot holders—you'll find this light-hearted idea will catch on quickly. For gay gifts and cheerful kitchens, make these brand new pot holders..." The first offering for pot holder-of-the-month is "Circus Clown."

The format of this book is quite interesting, having different, often theme-based, pot holders presented for each month: January–Party Favor, February–Irish Rose and Sunflower (neither looking anything like their name), March–KP Duck and Lucky Clover, April–Parasol and Easter Egg, May–Sweet Daisy and Bull's Eye, June–Grapefruit and Striped Bass, July–Fan Fair and Lady Bug, August–Cape Cod and Ship's Wheel, September–Mock Turtle and Penguin, October–Pumpkin and Bird Cage, November–Pink Pig and Palette, December–Snowman and Xmas Tree. The January pot holder was actually a handle cover that one would slide over a metal pot or pan handle allowing ease in gripping. This is the earliest example of this type of pot holder I could find.

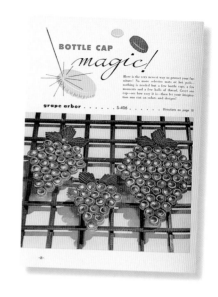

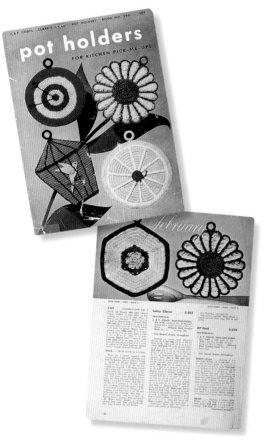

"Bottle Cap Crochet" is included in *Table Magic* (Coats & Clark Inc., c. 1953). "Here is the very newest way to protect your furniture! No more asbestos mats or hot pads—nothing is needed but a few bottle caps, a few moments and a few balls of thread. Cover one cap—see how easy it is—then let your imagination run riot on colors and designs!" Directions for a number of designs are included, but of particular interest is "grape arbor" crocheted in a variegated purple thread to resemble a bunch of concord grapes. Nineteen bottle caps were needed to complete a pot holder, thirty to create a medium mat, and fifty-four to crochet a large mat. To enhance realism, green leaves were made from felt. Today these are among the most elusive and most popular of hot pad designs. Notice, too, that the term "pot holder" is evolving to "hot pad." Newer plastic handles reduced the cook's dependence on true pot holders. However, the color and whimsy that was added to the kitchen, along with the pride of knowing one had created these pieces, perpetuated the notion that hand crocheted accessories were still a necessary item.

A colorful array of pot holders was presented in *Pot Holders Hot Plate Covers Swedish Embroidery* (The American Thread Company, c. 1953) where it was stated that Pot Holders would: "Keep fingers from burning, [make] Bright kitchen accessories [and] Grand gifts." These were not to be confused with Hot Plates that "Keep table tops unmarred [are] Good church and bazaar suggestions [while providing] Table conversation pieces." However, the line between pot holders and hot plates is blurring. It is interesting to note that another "Handle Holder Cover" is presented in this book that has primarily round and square pot holders.

All of the previously cited books sold for a mere ten cents. For twenty-nine cents in 1964 one could still purchase books that included hot pad instruction. Coats & Clark's Sales Corporation's *Kitchen Crochet* included directions for eight different Pot Holders. Most of these were actually for Hot Plate Mats having matching Pot Holders. These sets had the same design, but the Hot Plate Mat tended to be several inches larger and the Pot Holder had a sewn ring to allow for hanging. By this time, the only difference between a mat and a holder is a slight variation in size and the existence of a loop or ring for hanging. The line distinguishing the two is almost totally gone.

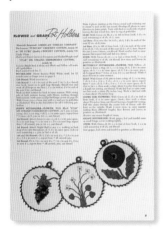

Pot holders were included in *New Quick Tricks to Crochet and Knit* (Coats & Clark Inc., c. 1954). Promoted as "the finest collection of Best Sellers that ever graced a Bazaar" designs ranged from a relatively unimaginative "Square Pot Holder" to the "Sugar 'n Cream Pot Holder Set" that had a pair of pot holders shaped like a cream pitcher and a sugar bowl. The growth of civic and church sponsored bazaars provided working women an opportunity to add handcrafted items to their décor even when their own schedule didn't allow the time for crafts and handiwork.

Today's collectors rarely differentiate between a real and true Hot Plate Mat and Pot Holder. Selection for purchase is usually based on colors that match an existing palette and the specific design—round, square, realistic shape, etc. Some examples are bought with the intension of hanging them, so a loop or ring becomes convenient, but not necessary, and others are purchased to use as doilies under collectible objects. Whatever the reason, collectors want clean, unstained handiwork that shows little or no wear. Pieces made with smaller crochet hooks and finer threads resulted in

more intricate detail and tend to be quite popular. Crocheting objects d'art for the kitchen is a lost art. Few women have the time, and even fewer have the knowledge to produce the gems shown in the following pages. As most selections are base on color, the examples provided are so arranged.

About the Prices

This book is designed to be a tool and reference for the dealer and the collector alike. Values vary immensely according to the condition of the piece and the quality of workmanship. Prices in the Midwest differ from those in the West or East and at antiques shows. Remember, too, that being in the right place at the right time can make a tremendous difference. All of these factors make it impossible to create absolute prices, but I strive to offer a guide that reflects what one could realistically expect to pay at the time of publication. The prices in this book are for individual items that are in excellent condition.

Neither the author nor the publisher is responsible for any outcomes resulting from consulting this reference.

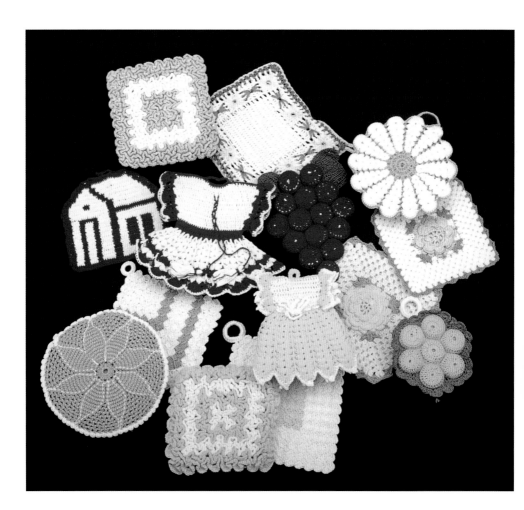

Red

Often mistaken as a fifties color, Mandarin Red was one of the three original kitchen colors introduced in 1927. The popularity of using red as an anchor color in kitchen decor has never waned, allowing us, seventy-five years later, a wonderful legacy of red decorating options. Our retrospective of Pot Holders and Hot Pads begins with this, the undisputed most popular color with contemporary collectors.

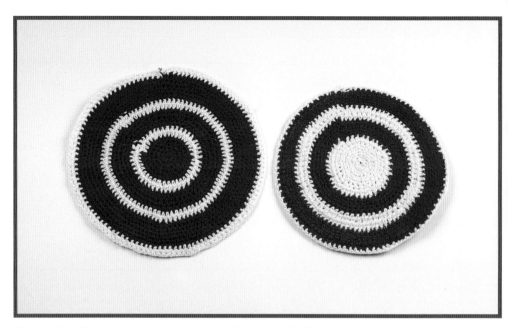

These pot holders represent as simple a stitch as possible from a 1943 pattern. However, these pair together nicely as they are a positive-negative use of color. One is primarily red with white stripes and the other is white with red stripes. $6-8 each

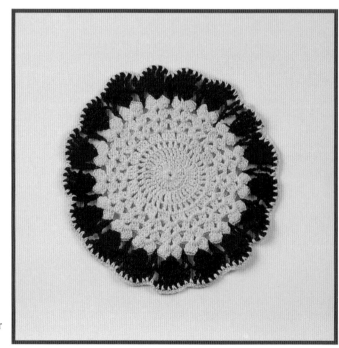

Two pieces are bound together with off-white stitches. $8-10

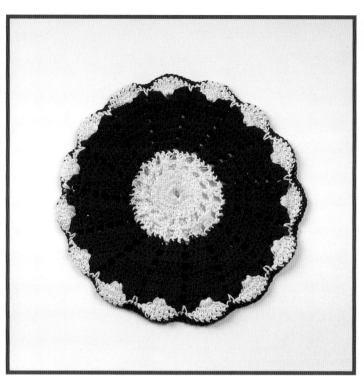

A simple use of color results in a lovely pot holder. $8-10

The rolled-under edges indicate that this was crocheted to be stretched over an asbestos mat, an idea introduced in the early 1950s. $8-10

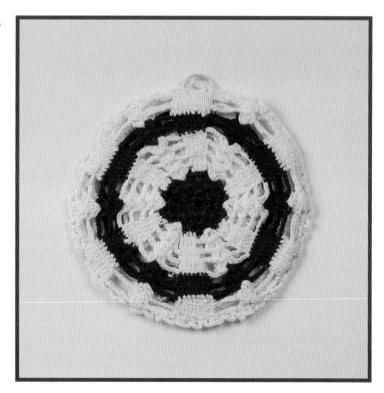

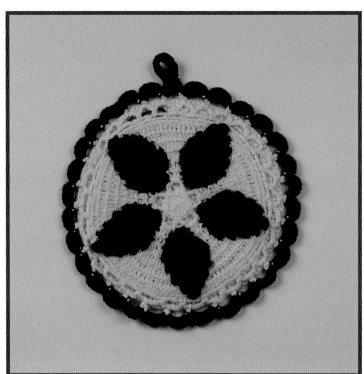

The hex sign-like flower is crocheted with a pebble texture. $8-10

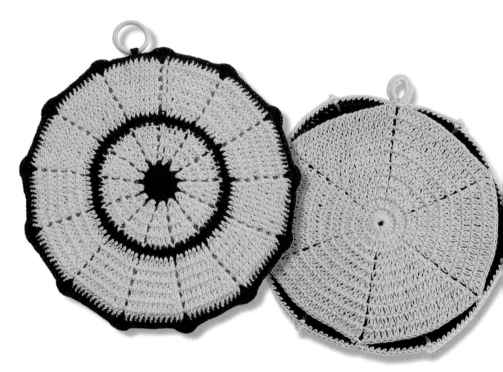

There is a true front and back to this pot holder, but the back side is still quite artistic. $8-10

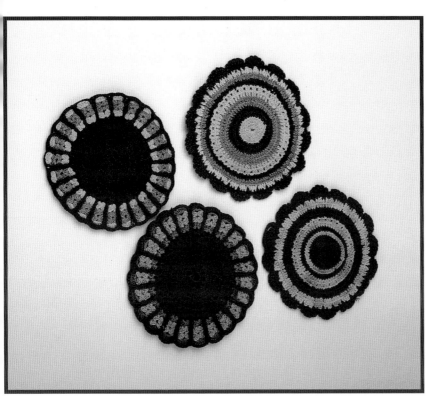

A touch of color can customize a pot holder or hot pad
mat with the kitchen in which it will be used. $8-10 each

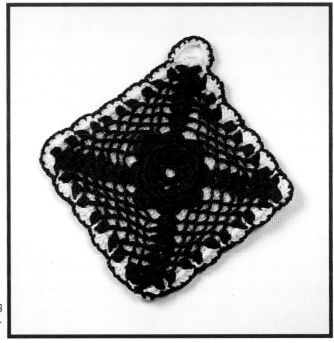

It is rare to find a rosette having
no green accents in the design.
$8-10

Scalloped edges enhance the beauty of these pot holders. $8-10 each

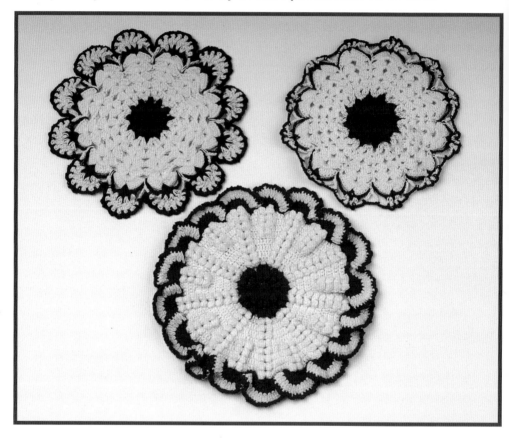

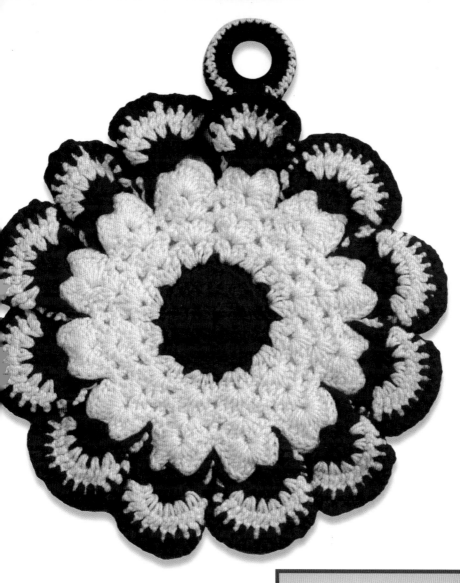

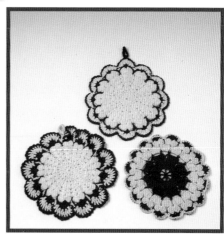

Scalloped edges enhance the beauty of these pot holders. $8-10 each

A simple sunflower design from 1952 is still popular with collectors. $8-10 each

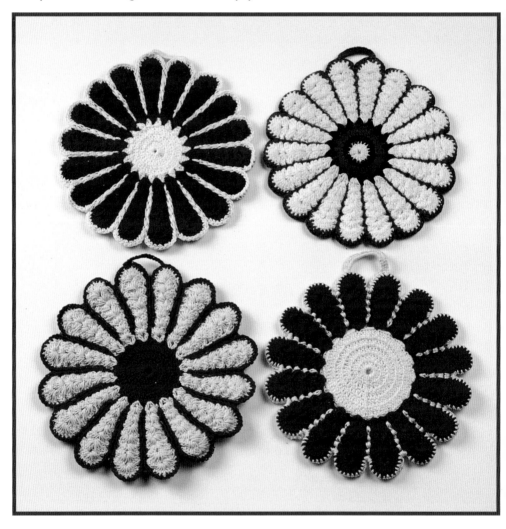

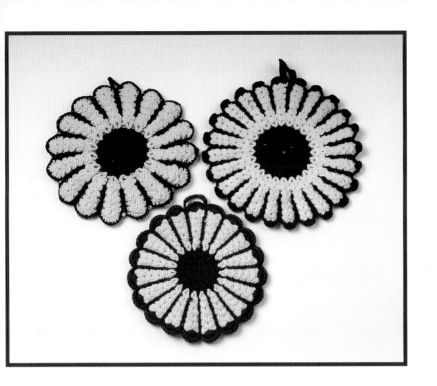

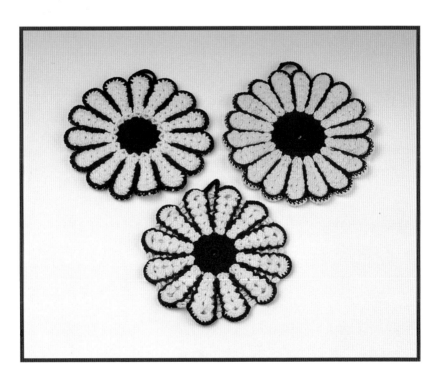

The addition of flowers to the crocheted design was introduced in 1950. Whether round or square, those having a rosette are among the most popular pot holders with today's collectors. $8-10 each

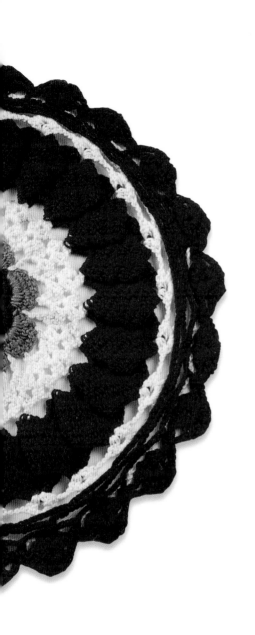

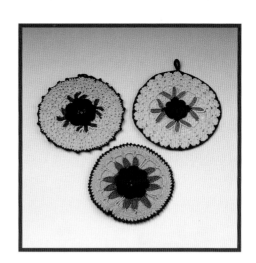

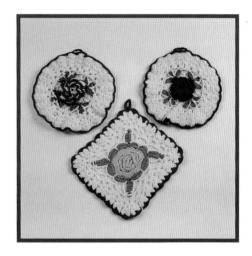

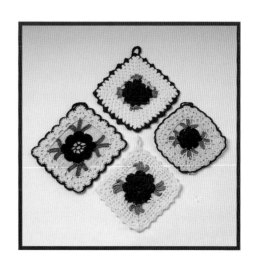

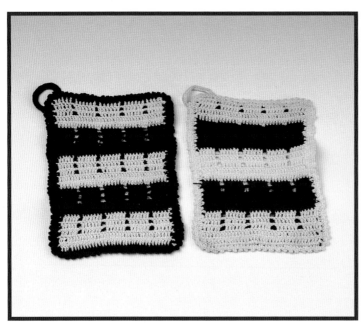

This pair of pot holders wa[s] made to be displayed together as one is red with white and the other white with red, another example of positive-negative handiwork. $8-10 each

Here are two checkerboard pot holders from 1943 designs. Notice that one has a crocheted loop and other a bone ring. $8-10 each

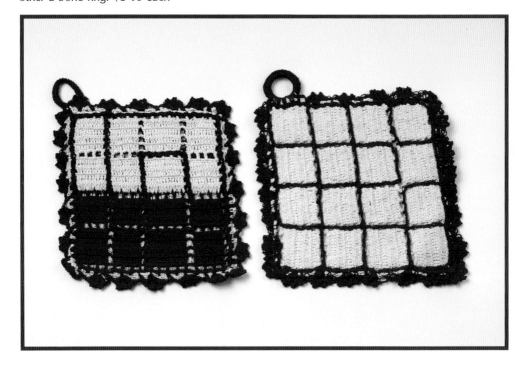

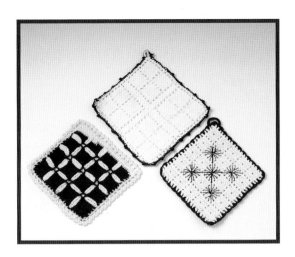

Turning a square on an angle creates a diamond-shaped pot holder. $8-10 each

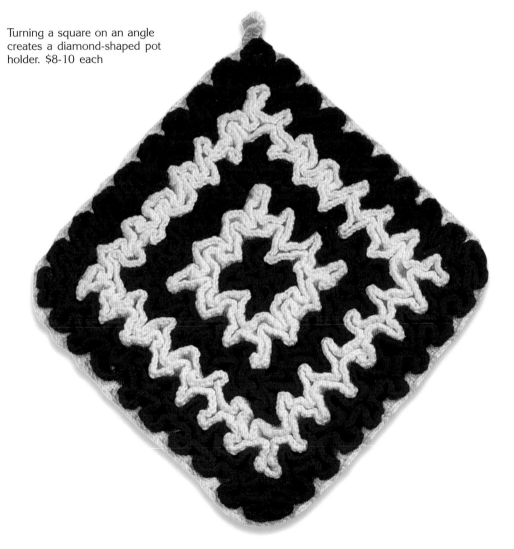

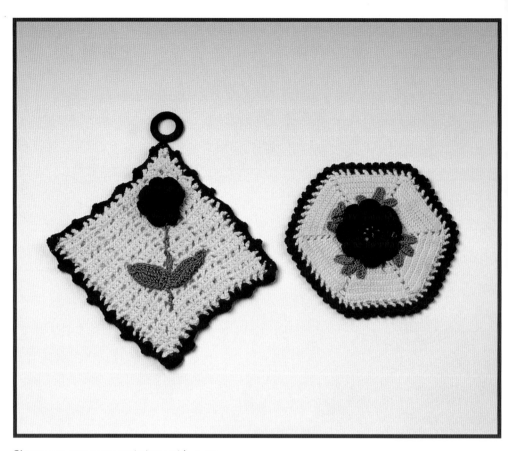

Shown are two more variations with a crocheted rosette. $8-10 each

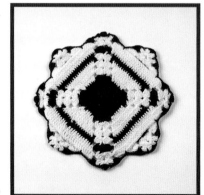

This is an unusual design created with two pieces, one positioned as a square and the other pivoted to become a diamond. $10-12

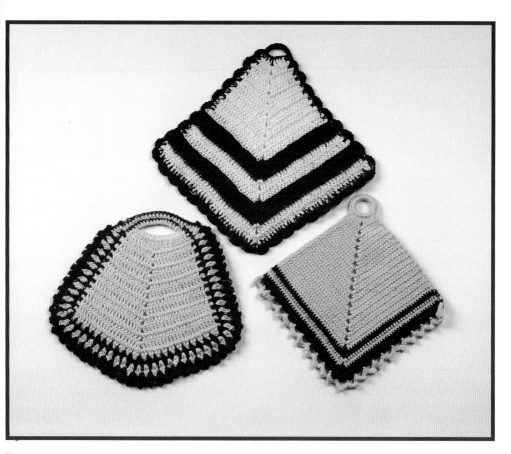

These true diamonds are designs introduced
in 1943. $6-8 each

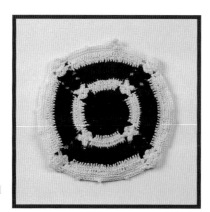

Here is an unusual pot
holder that is neither round
nor square. $8-10

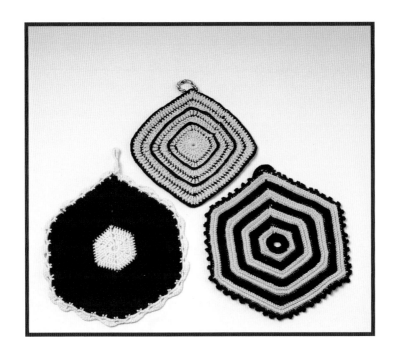

Shown is an assortment of four-, five-, and six-sided pot holders. $8-10 each

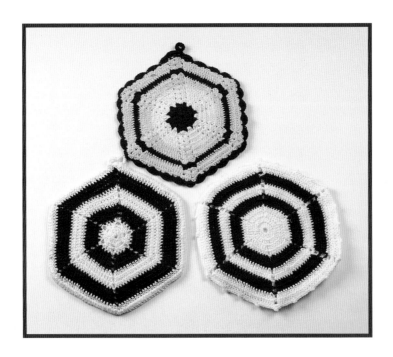

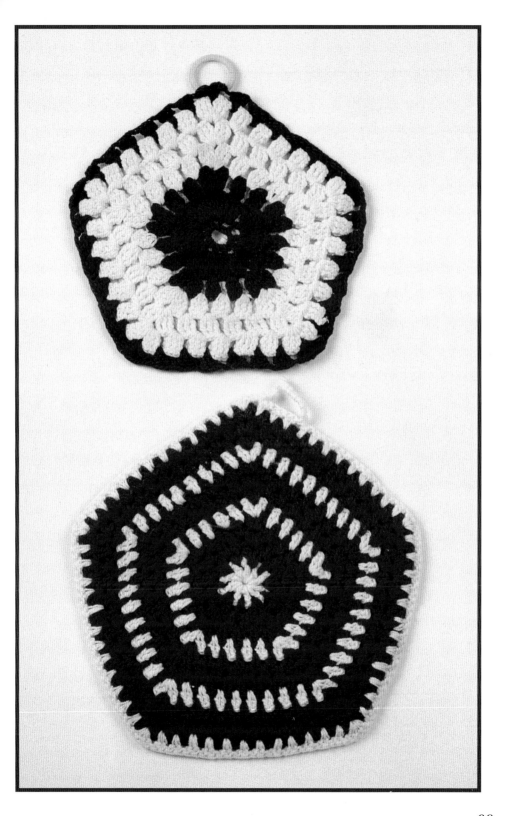

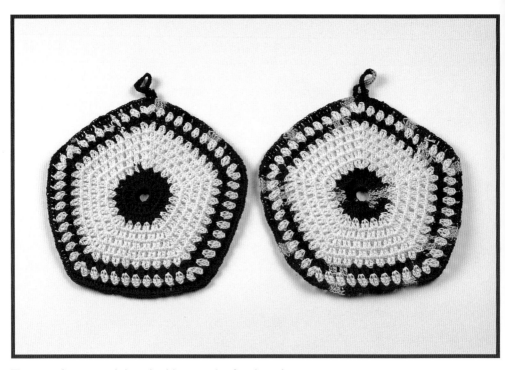

The use of variegated thread adds a touch of pink to this
pair. $8-10 each

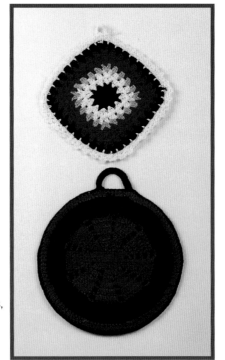

Black and red kitchens
were popular in the 1950s,
and here are two pot
holders that would have
been wonderfully appro-
priate. $8-10 each

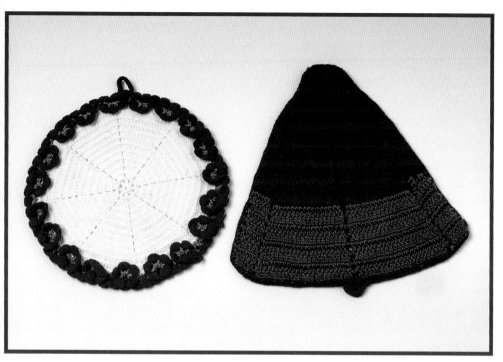

With the addition of green thread, red pot holders become perfect for Christmas displays or gift-giving. Circle, $8-10; bell, $15-18

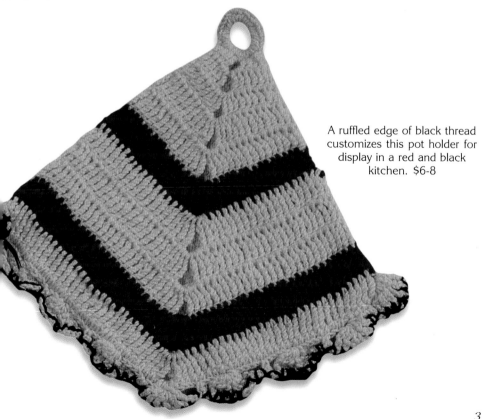

A ruffled edge of black thread customizes this pot holder for display in a red and black kitchen. $6-8

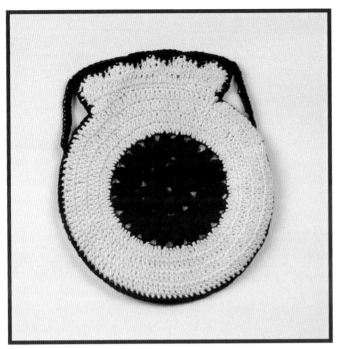

Realistically shaped pot holders are difficult to find.
This urn-like example is meant to be a sugar bowl.
Perhaps its maker had crocheted a matching cream
pitcher. $15-18

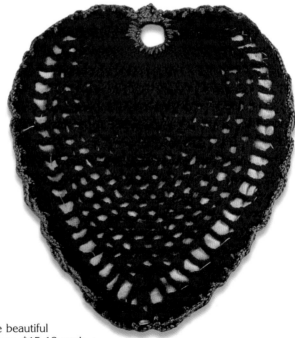

A strawberry and an apple are beautiful
examples of realistic pot holders. $15-18 each

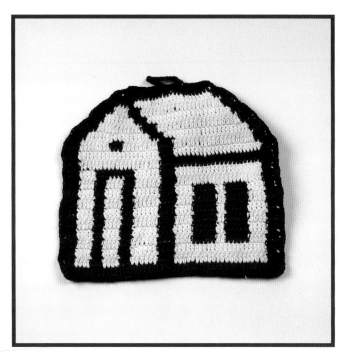

Home Sweet Home—a lovely realistically
shaped pot holder. $15-18

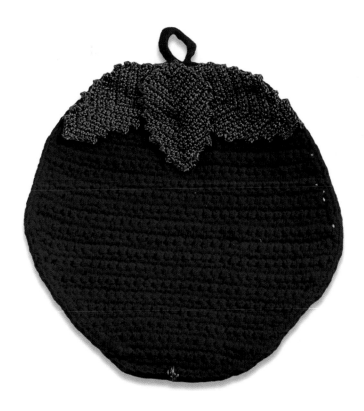

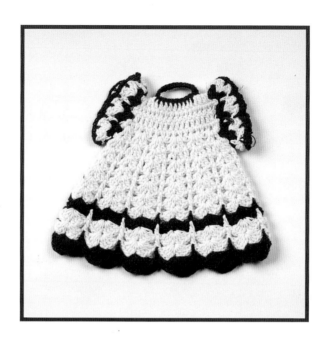

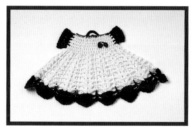

Introduced in 1947,
dresses and panties
are favorites today.
$12-15 each

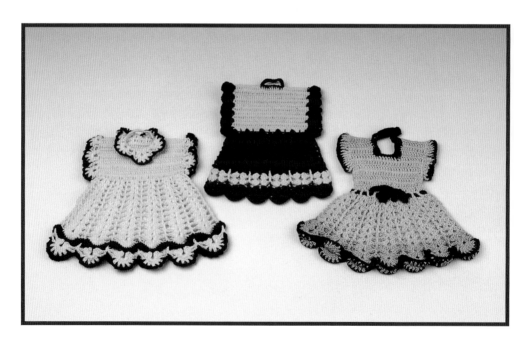

34

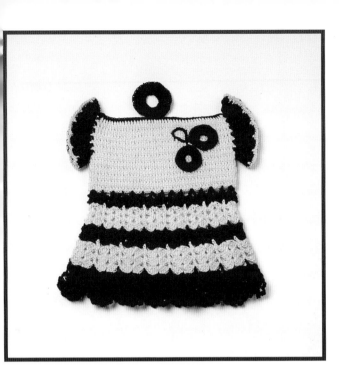

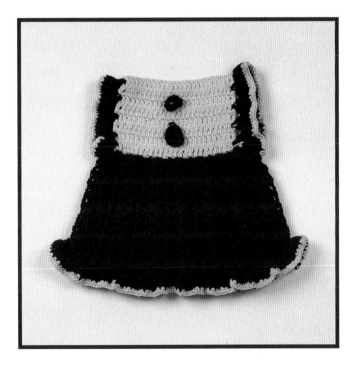

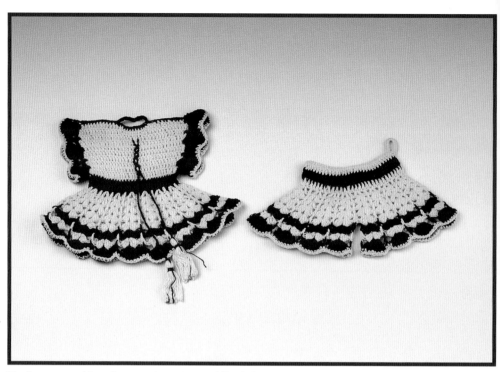

Finding a matching dress and panties is difficult but not impossible. Dress, $12-15; panties, $10-12

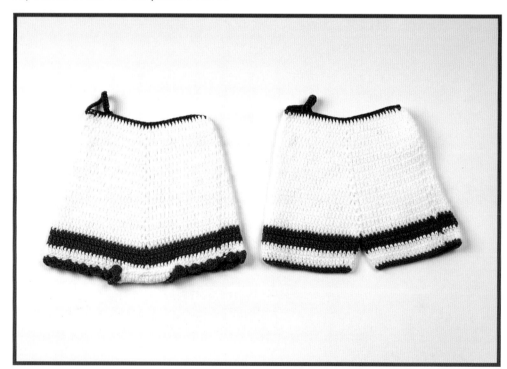

The same person probably crocheted these similar panties. $10-12 each

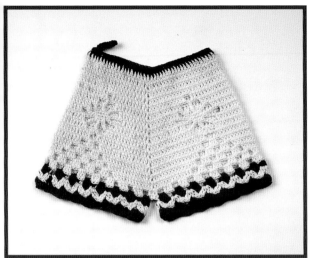

Texture adds interest to this pair of panties. $10-12

Here is an unusual set of "His" and "Hers" panties. $10-12 each

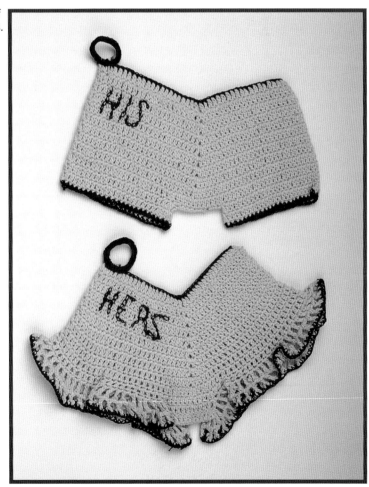

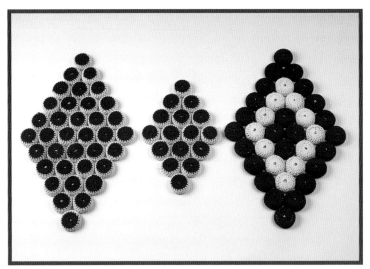

Introduced in 1953 as a way to eliminate the use of
asbestos mats, bottle cap hot pad mats are very popular
today. $12-15 each

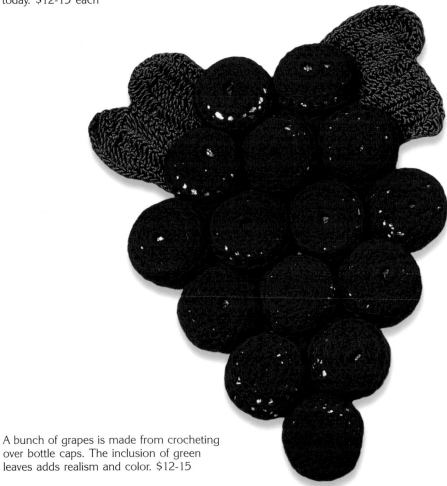

A bunch of grapes is made from crocheting
over bottle caps. The inclusion of green
leaves adds realism and color. $12-15

Crocheting around 3/4" bone rings was
introduced in 1953. $8-10

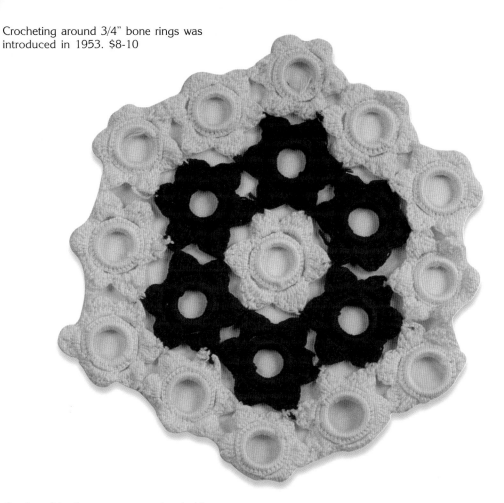

Crocheted baskets were created to hold one,
two, or three pot holders in coordinating
colors and stitches. $10-12 each

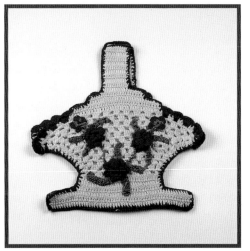
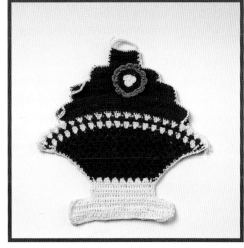

Chapter Two

Red, White & Blue

Blue and red were two of the original colors offered to consumers in 1927 and both have remained popular ever since. After the tragedy of September 11, 2001 a renewed sense of patriotism swept across the United States. Fortunately vintage kitchen collectibles in red, white, and blue have survived. A sample of some pot holders shows the array of shapes and combinations that one can find.

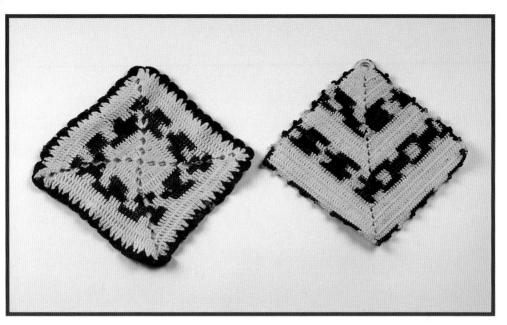

The use of variegated red, white, and blue thread creates a burst of colors that add interest to otherwise plain handiwork. $8-10 each

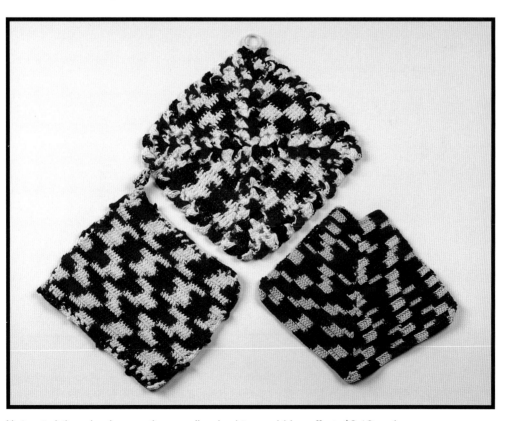

Variegated thread enhances the overall red, white, and blue effect. $8-10 each

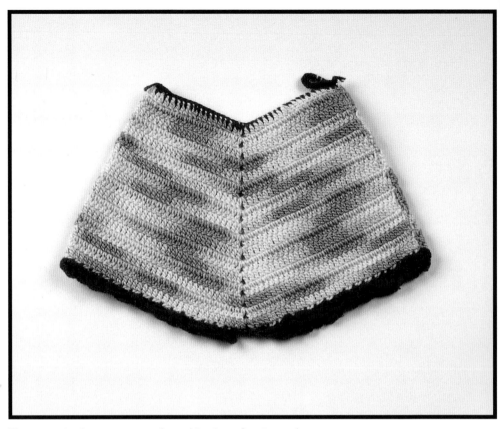

These panties have an unusual combination of variegated
blue and white thread with a red trim. $10-12

Also trimmed with red thread, this
diamond-shaped pot holder is largely
completed in textured blue. $8-10

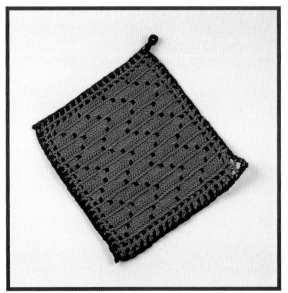

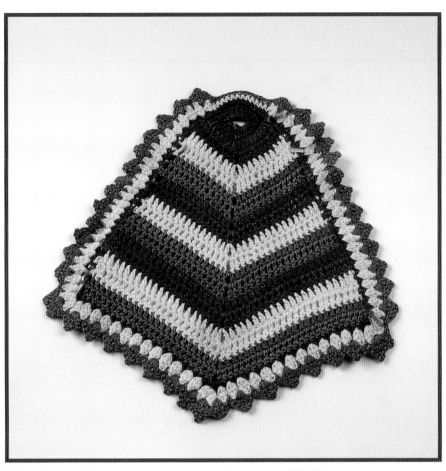

Red, white, and blue can be extra patriotic with stripes. $10-12

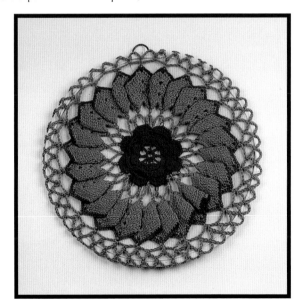

Close examination reveals the asbestos mat under this circle of red, white, and blue. $8-10

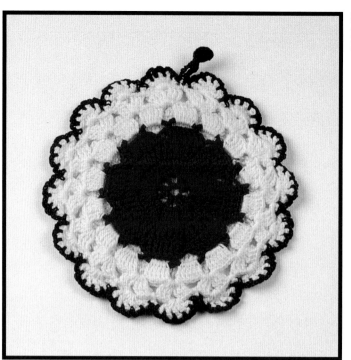

Simple use of color provides a round patriotic pot holder. $8-10

A single chain of green highlights the red flower in the center of this asymmetric design. $8-10

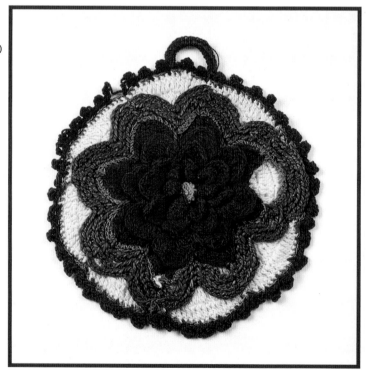

Chapter Three

Blue

Blue has been an anchor color in kitchen décor ever since its introduction in 1927. The spectrum of shades is quite broad, and, if an exact color match is important, one should shop with a color-matched example. From royal blue to turquoise to baby blue the options are numerous. The examples that follow present an array of shape and style as well as hue.

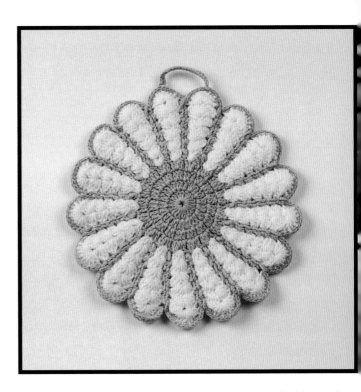

A simple sunflower design from 1952 is still popular with collectors. Shown are light blue and turquoise. $8-10 each

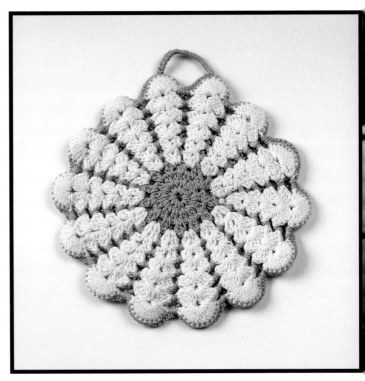

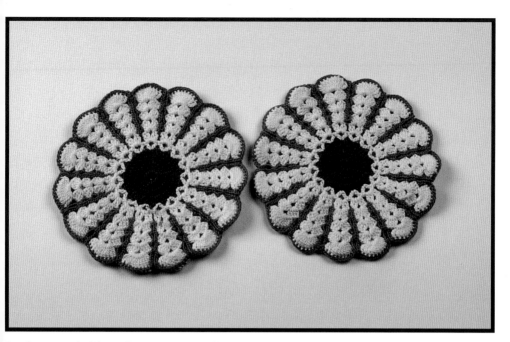

Sunflower pot holders take on a totally different look in darker shades of blue and with a variegated center. $8-10 each

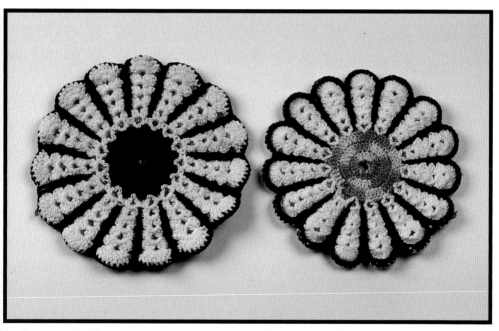

Sunflower pot holders take on a totally different look in darker shades of blue and with a variegated center. $8-10 each

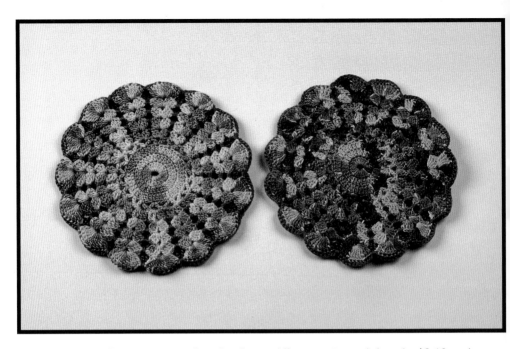

These colorful sunflowers were crocheted with two different variegated threads. $8-10 each

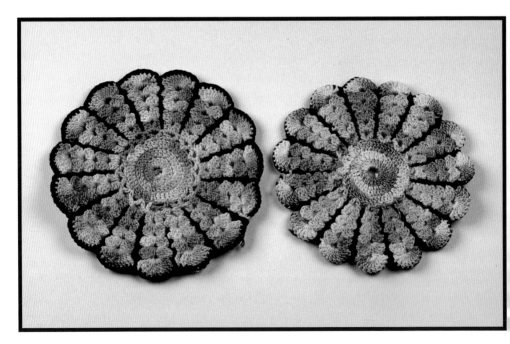

Yellow variegated petals are highlighted in royal blue. The sunflower on the left is trimmed in blue variegated thread in the center and along the outer edges. $8-10 each

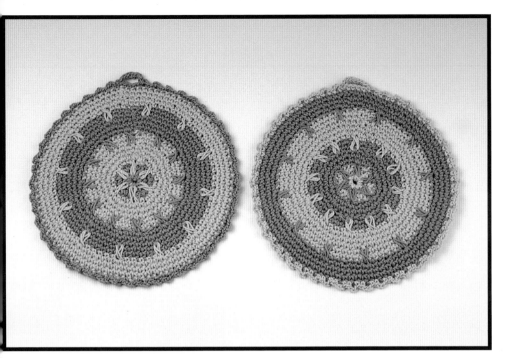

Here is a pair of a positive-negative pot holders. Where one is blue the other is buff, and where one is buff the other is blue. These were obviously created by the same person and fortunately they have remained a pair. $8-10 each

Pink and yellow stripes add detail to a sunflower variation. $8-10

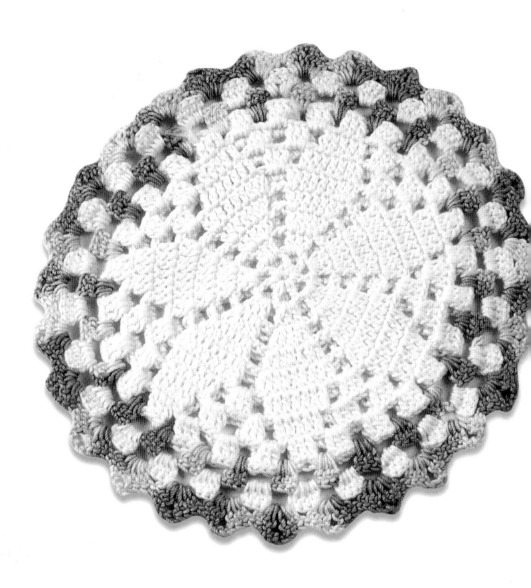

A pastel variegated thread adds color to the edge of a round hot pad mat. $8-10 each

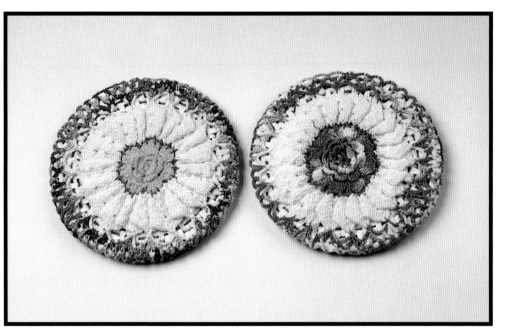

Floral rosettes add dimension and color to a pair of hot pad mats. Note the subtle color variations between the outer edges. $8-10 each

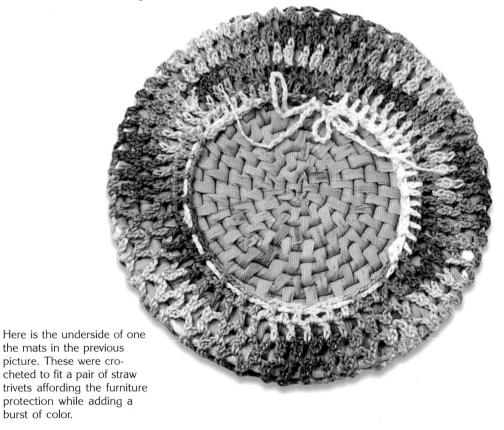

Here is the underside of one the mats in the previous picture. These were crocheted to fit a pair of straw trivets affording the furniture protection while adding a burst of color.

Whether called "Merry-go-round" in 1941 or "Indian Circle" in 1947 variations of this pinwheel abound. $10-12

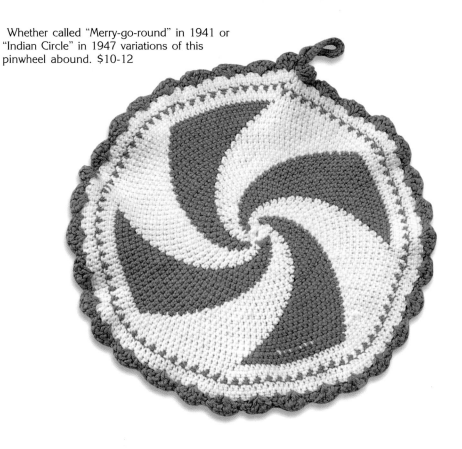

Yellow was the most important fifties color. Here are two examples of yellow and blue in round designs. $8-10 each

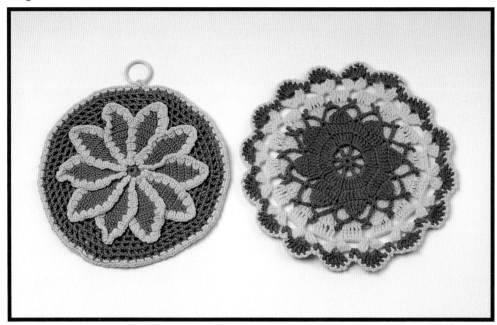

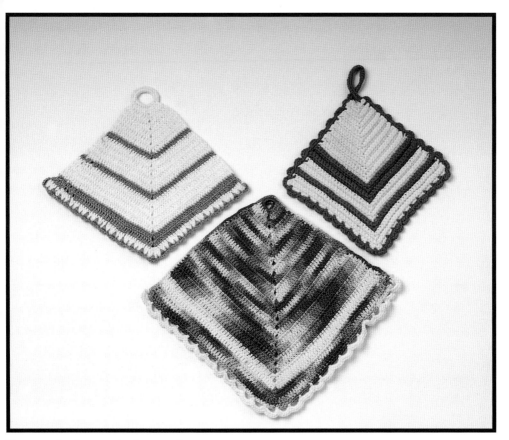

The use of color greatly changes the appearance of these diamonds completed in a 1943 design. $8-10 each

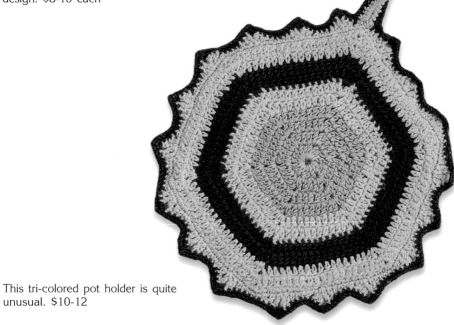

This tri-colored pot holder is quite unusual. $10-12

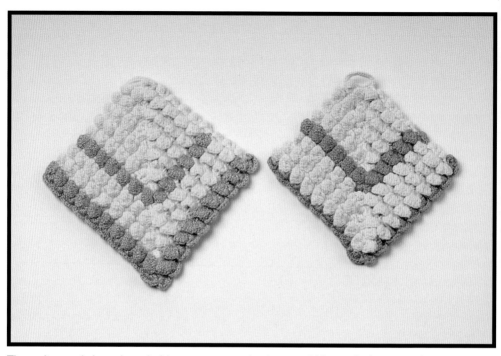

These diamond-shaped pot holders were created using a pebble stitch that gives them the appearance of being made from chenille. $8-10 each

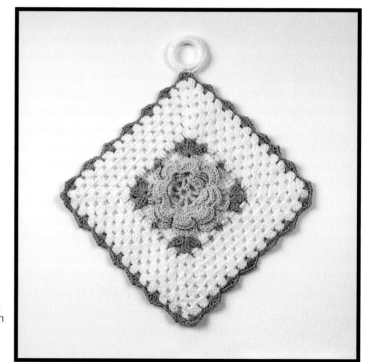

Rosettes from the early 1950s are among today's favorites. The pink rosette in this hot pad makes it an appropriate color choice for blue or pink kitchens. $8-10

Shown is a simple pot holder trimmed in cream thread. $8-10

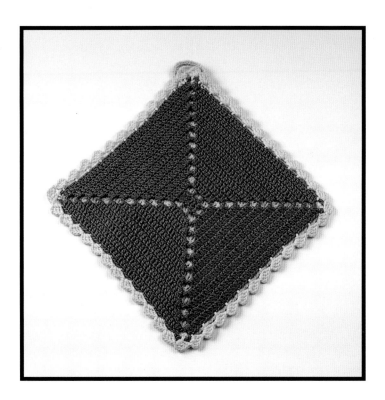

Here is a beautiful example of positive-negative pot holders with rosettes. These were obviously made by the same person and look magnificent when displayed in tandem. $8-10 each

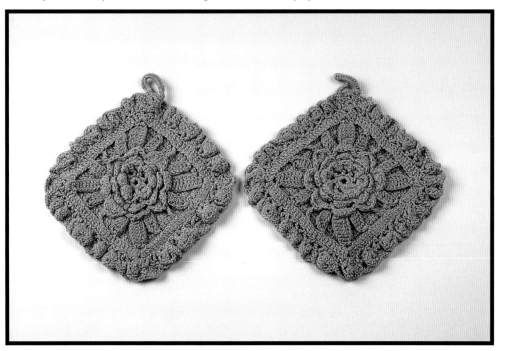

The use of color can greatly change the look of piece. Yellow and blue variegated threads were used to complete this hot pad mat. $8-10

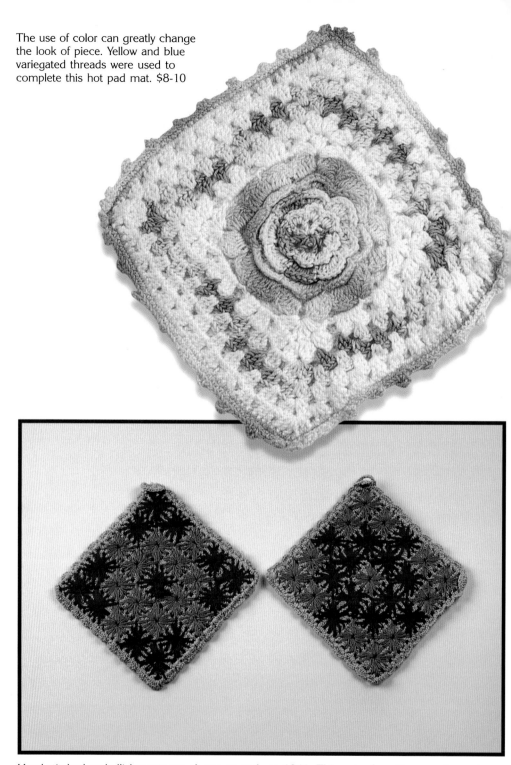

Hand-stitched embellishments are shown as early as 1941. This pair of positive-negative pot holders is a unique example of both the use of positive-negative coloration and surface stitching details. $8-10 each

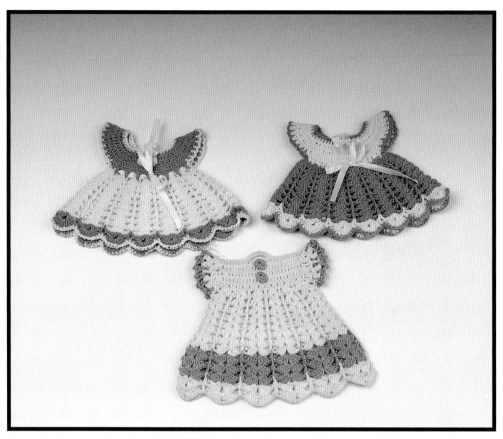

Dress designs were introduced in 1947. Details such as pearl buttons and ribbons greatly enhance the charm of these already adorable examples. The two examples at the top of this picture are a positive-negative pair. Note that where one is turquoise the other is cream and where one is cream the other is turquoise. $12-15 each

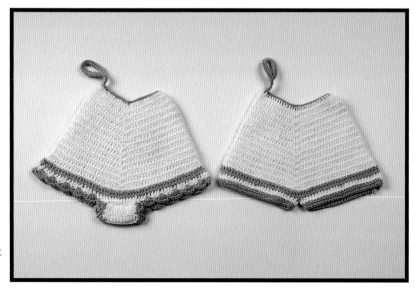

Shown are two pairs of panties trimmed in light blue. $10-12 each

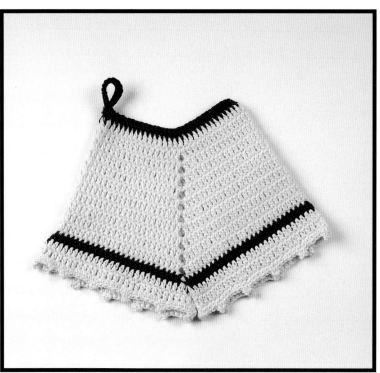

Royal blue trim greatly affects the appearance of this pair of panties. $10-12

Trimmed in ecru, these panties are shown in a rich, deep blue. $10-12

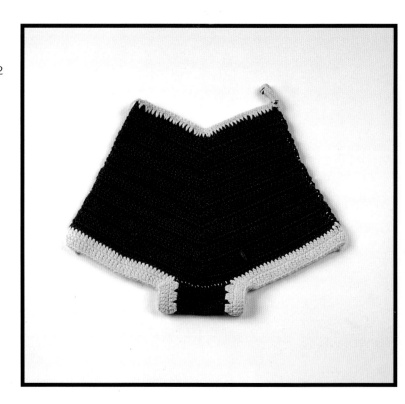

This pair of panties was created with a very simple stitch and edged with a feminine ruffle. $10-12

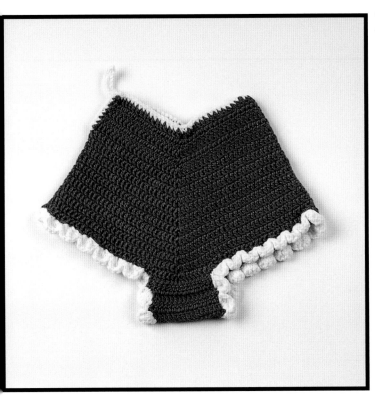

Reminiscent of Easter bonnets, this pair of pot holders is truly unique. The floral embellishments added to the example on the left dates this to no earlier that 1950. $15-18 each

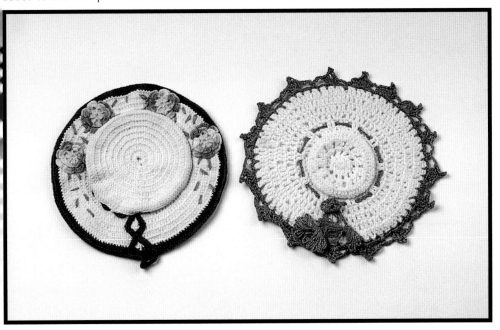

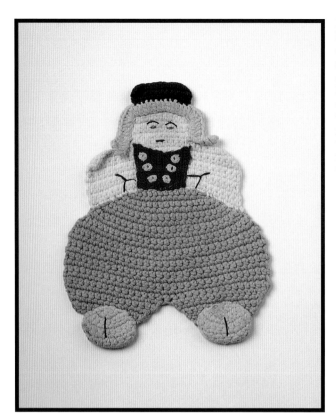

Perhaps at one time the Dutch boy had a Dutch girl as his companion. Made with basic stitches, the color changes and different lengths of rows make him a difficult fellow to create, yet stains indicate that a homemaker was content placing hot casseroles directly on him. Years ago the thought was to protect the furniture; now we seek to protect these works of art! $18-20

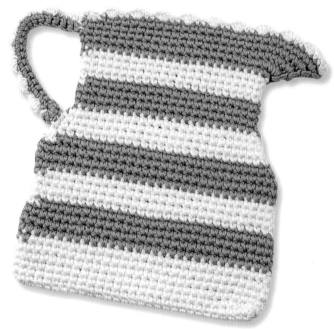

Broad bands of white and blue add to the charm of a striped cream pitcher that may have had a matching sugar bowl. This was made from two pieces stitched together on three sides. The top is open allowing one to insert a hand to utilize this as a mitt. $15-18

Chapter 4

Green

Apple green was introduced in 1927, and from then until now green in one shade or another has remained a dominant color in American kitchens. Apple green led to jadeite, a color of glassware that was manufactured until the 1970s and reproduced in the 1990s. Transparent green glass was introduced in the late 1920s and continued until the early 1940s. Forest Green was introduced in the 1950s and avocado green in the 1960s.

Whether decorating as a basic color or for the Christmas holidays, green is a comfort color that most people find relaxing and refreshing. The handiwork shown in this chapter offers a broad assortment of hues and designs.

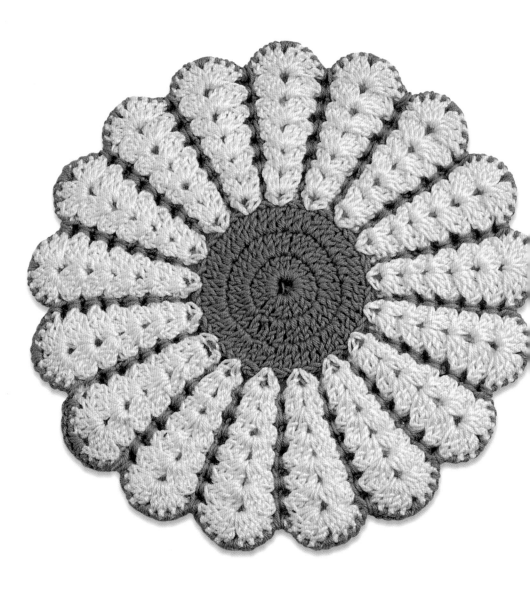

The simple sunflower design from 1952 is still popular with collectors. $8-10 each

The simple sunflower design from 1952 is still popular with collectors. $8-10 each

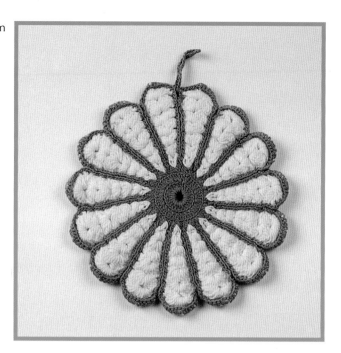

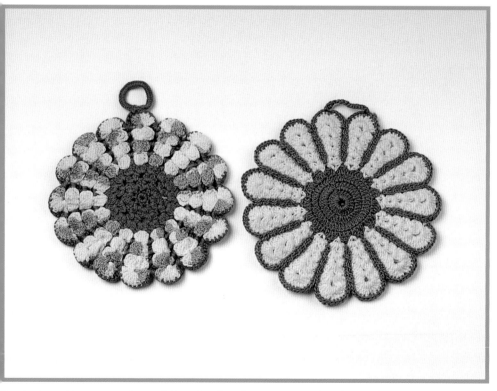

Crocheting with green variegated thread rather than cream makes the sunflower pot holder look very different. Variegated thread in green is less common than other colors in pot holders and hot pad mats. $8-10 each

Cream and green pot holders are shown in similar designs. $8-10 each

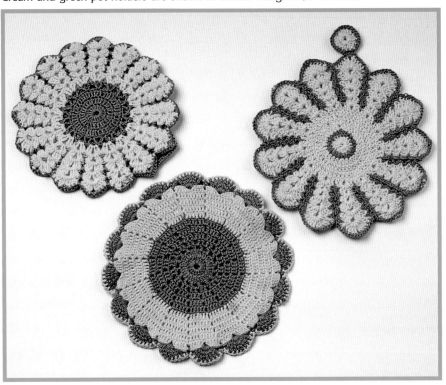

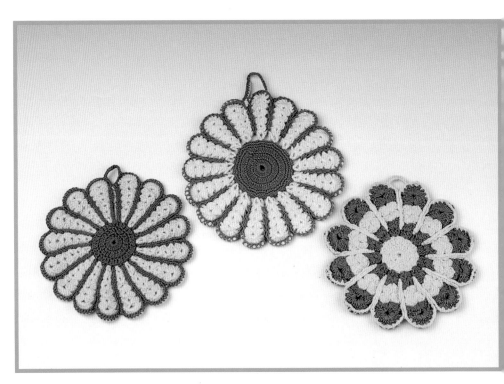

A dimensional ruffle along the edge creates a particularly decorative pot holder. $8-10

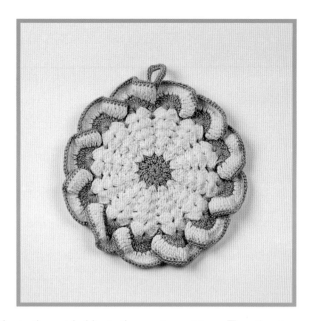

The hot pad mat on the bottom is similar to the pot holder in the previous picture. The other two are identical to one another except for size. This matched pair was crocheted with a glossy thread one rarely sees utilized in kitchen items. $8-10 each

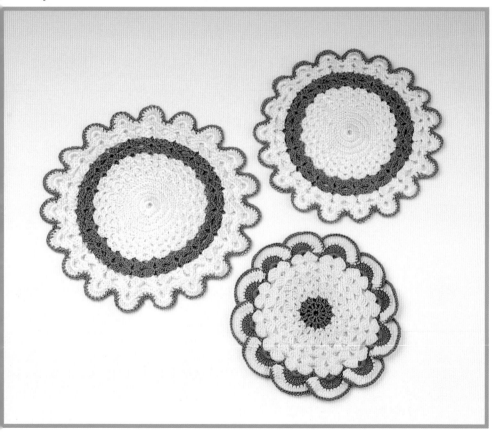

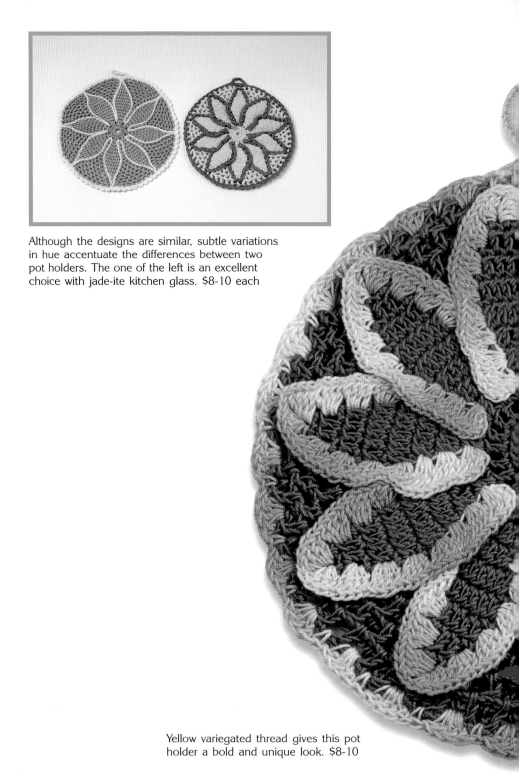

Although the designs are similar, subtle variations in hue accentuate the differences between two pot holders. The one of the left is an excellent choice with jade-ite kitchen glass. $8-10 each

Yellow variegated thread gives this pot holder a bold and unique look. $8-10

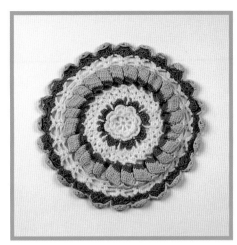

From the early 1950s, the ruffles of green and yellow overpower a white rosette. $8-10

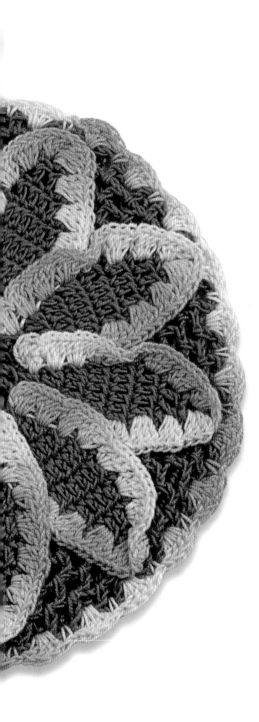

A lace-like second layer is underneath the decorative top done in green and oyster with a yellow rosette. $8-10

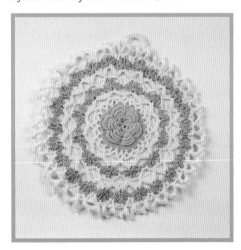

This mat with unexpected stripes of red and pink measures a mere 3.5". It is very tightly crocheted making it stiff and thick, thus affording extra protection to the furniture it was created to protect. $8-10

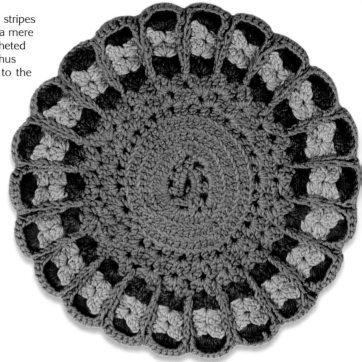

Variegated thread greatly alters the appearance of pot holders. The one on top is a basic circle in a simple stitch. The diamond on the bottom is from a 1941 design. The chevron-like band of off-white adds interest and style to an otherwise simple piece. Circle, $6-8; diamond, $8-10

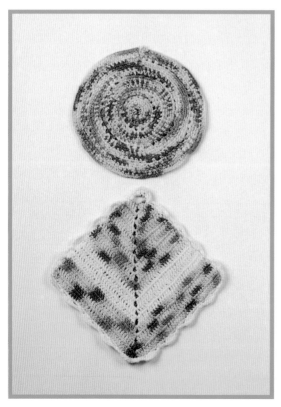

What a difference color makes! These three pot holders are similar in construction but look vastly different from one another. $8-10 each

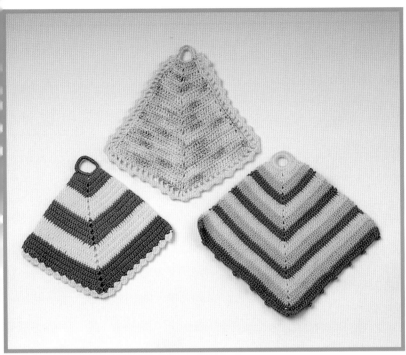

The textured stitch used in these positive-negative pot holders makes these diamonds appear almost soft to the touch. This pair is an excellent match for use with jade-ite. $8-10 each

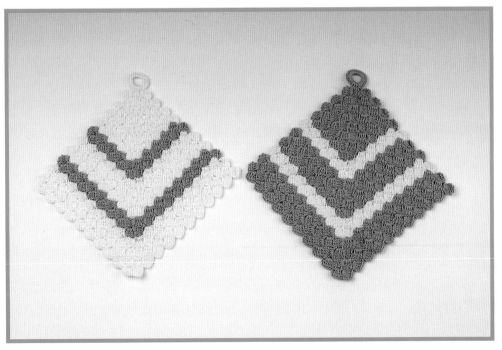

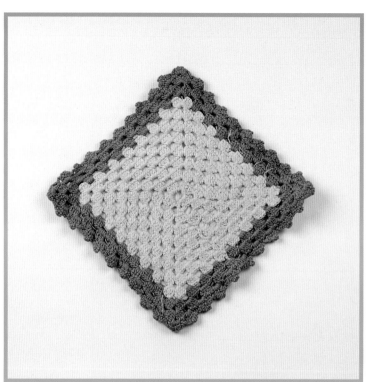

Shown is a simple use of two colors. $8-10

Small bands of green and variegated yellow create a dynamic design. $8-10 each

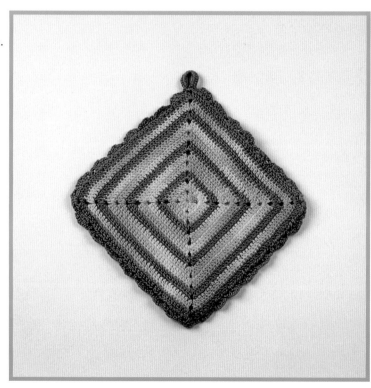

Diagonal bands of green and orange are in directional opposition textured bands. The use of orange is unexpected, but this pot holder would be outstanding with vintage red Fiesta dinnerware. $8-10

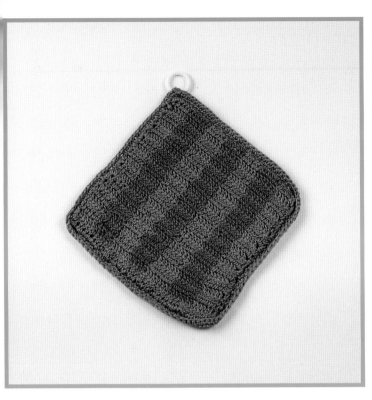

Green and pink look wonderful together as shown on a pot holder having a pink loop and pink embroidered flowers. $8-10

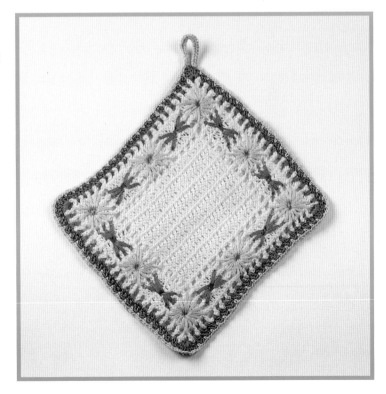

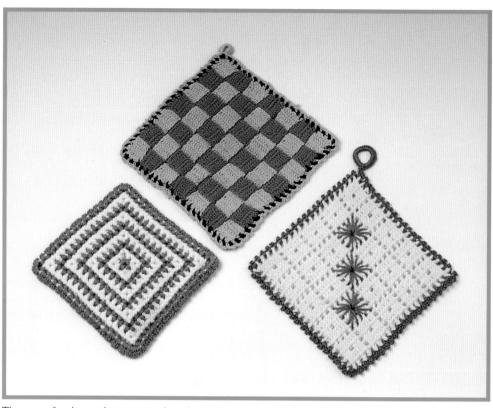

The use of color and texture makes three diamond-shaped pot holders look completely different from one another. The checkerboard design is from 1943. $8-10 each

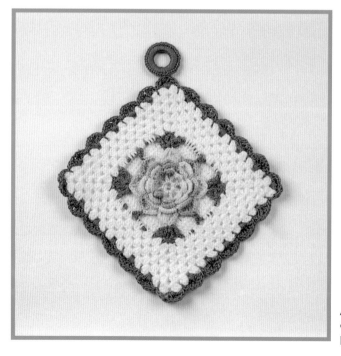

A rosette in variegated yellow dominates the design of a lovely pot holder. $8-10

Again one sees the compatibility of green and pink as shown on this example having a pink rosette. $8-10

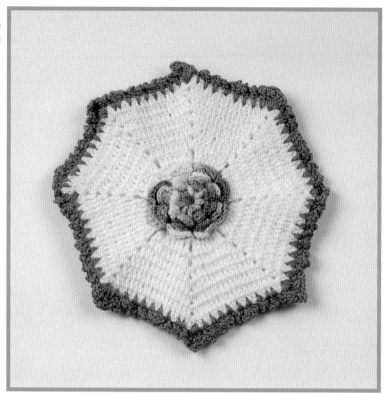

Rosette designs are from the early 1950s. The hot pad mat on the right is lined with yellow felt for additional heat protection. However, it creates a lovely touch as this color plays peek-a-boo from behind textured stitches. $8-10 each

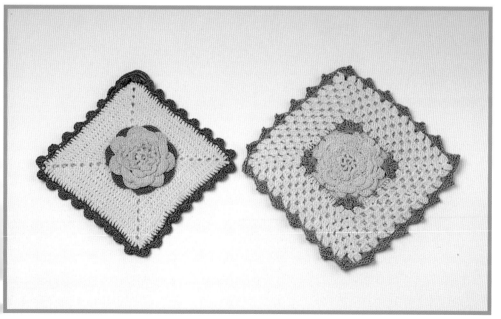

The yellow center of this hot pad mat is reminiscent of a rosette. $10-12

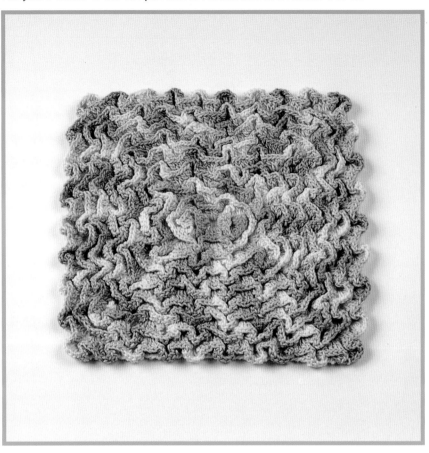

One side of this pentagonal pot holder is red, and the other side is green, great color options at Christmas. $8-10

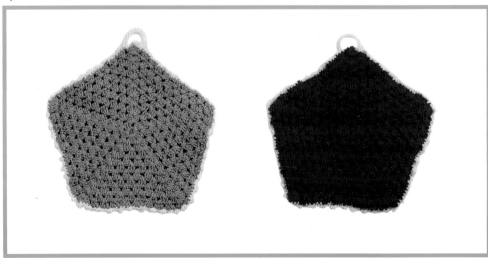

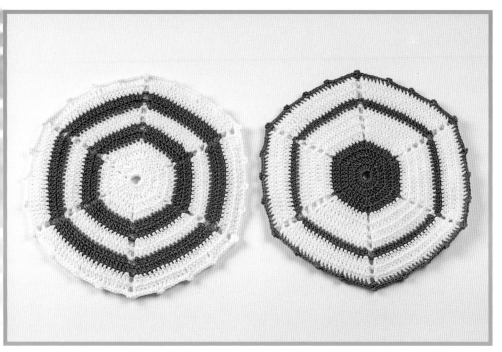

Pure white and deep green create a rich contrast in pieces competed with identical stitching, an excellent example of how the use of color effects overall presentation. $8-10 each

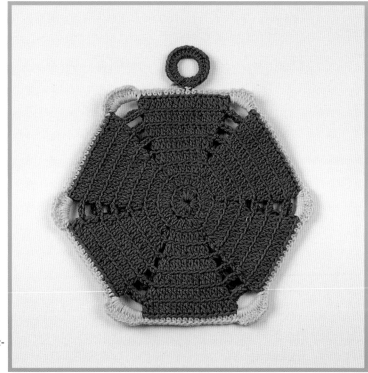

Two pieces are bound together with ecru stitching. Double layers create additional protection when handling hot objects. $8-10

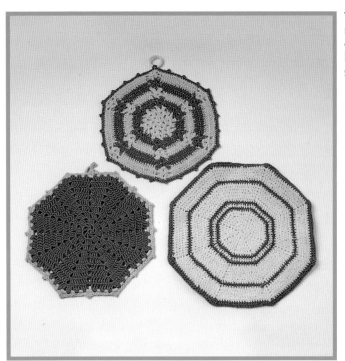

The use of color and texture make similar pieces look distinctly different. The pot holder on top was made using green metallic thread. $8-10

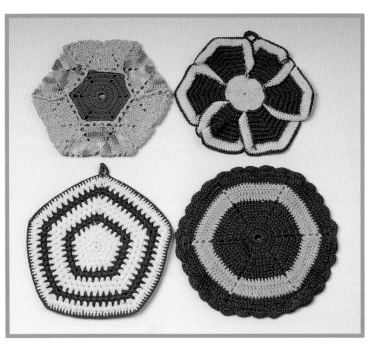

Although similar in size and shape, these four examples are vastly different. The pot holder in the upper left was made with yellow and variegated green crocheted pieces connected with oyster-colored stitching in a manner similar to creating a patchwork quilt. $8-10

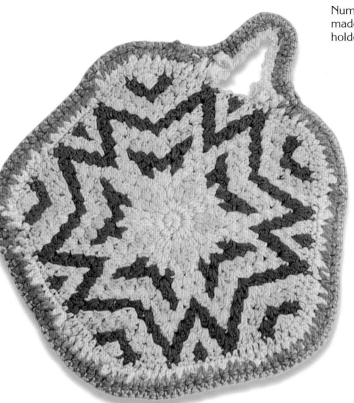

Numerous color changes were made to create this bold pot holder. $8-10

Both pieces are from 1953 designs. The one on top was created with only seven bottle caps making it almost too small to be useful. The one on the bottom is the "Buttercup Potholder" from *Pot Holders Hot Plate Covers Swedish Embroidery* (The American Thread Company, c. 1953). Top (bottle caps), $10-12; bottom, $8-10

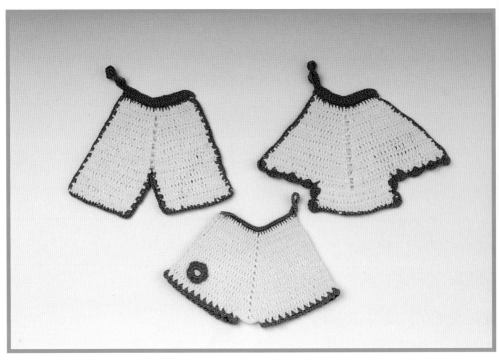

Introduced in 1947, dresses and panties are favorites today. All three of these pot holders were created with a single stitch in white and trimmed in green. $10-12 each

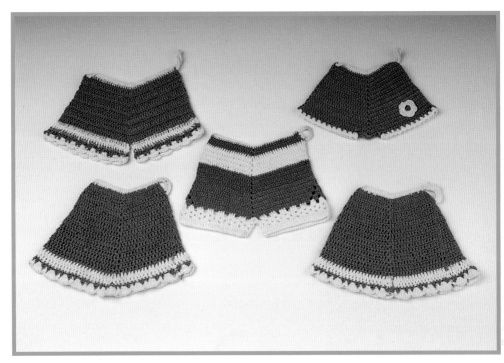

By using more green than white these panties have a bold, bright appearance. $10-12 each

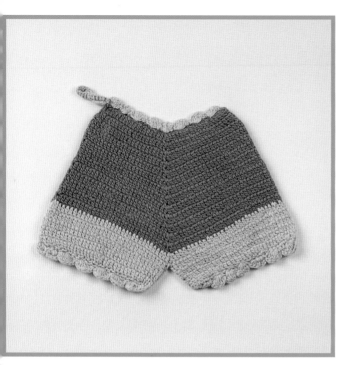

This pair of panties seems feminine due to the
pink at the waist and legs. $10-12

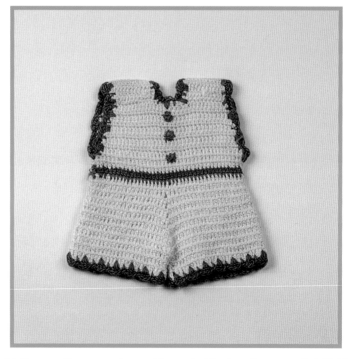

Neither panties nor a dress, this pot holder is quite unusual. $12-15

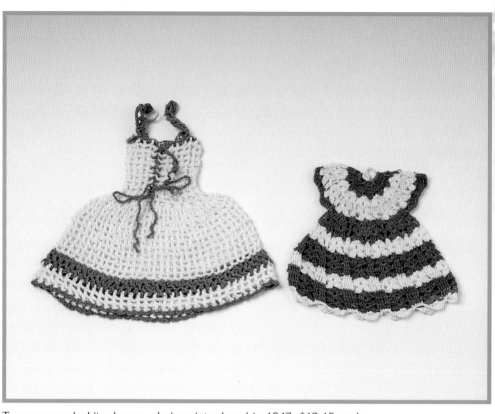

Two green and white dresses, designs introduced in 1947. $12-15 each

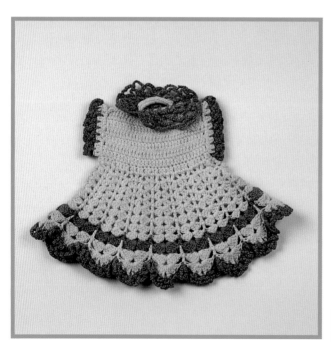

A decorative collar hides the loop from which this dress would be hung. $12-15

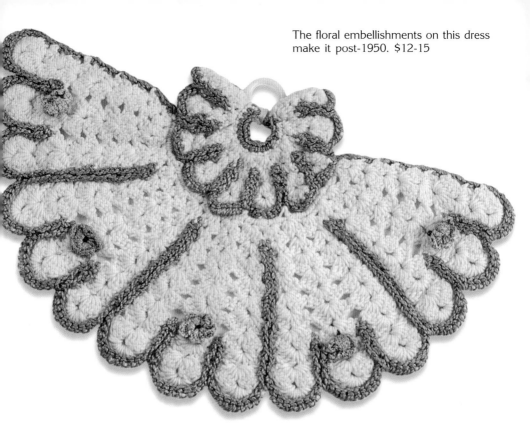

The floral embellishments on this dress make it post-1950. $12-15

Crocheted baskets were created to hold one, two, or three pot holders in coordinating colors and stitches. Basket, $10-12; circular pot holder, $6-8

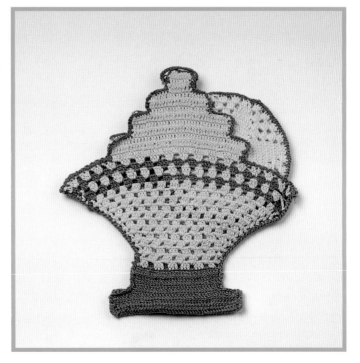

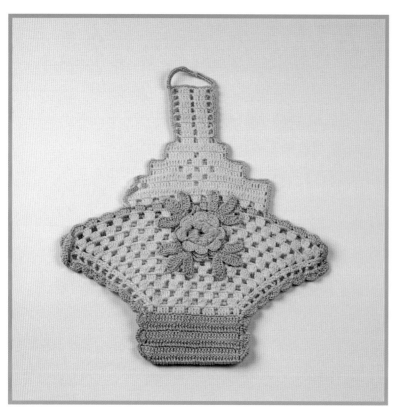

A yellow rosette adds color and interest to an otherwise plain basket from the early 1950s. $10-12

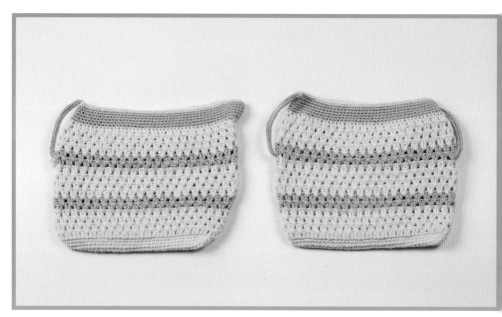

Most likely from the mid-1950s, this sugar and creamer set is crocheted in off-white and jade-ite green. $15-18 each

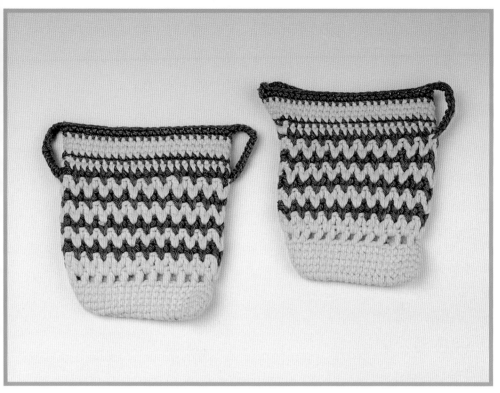

A decorative zigzag adds bold color reminiscent of ancient Greek pottery to a sugar and creamer set probably from the mid-1950s. $15-18 each

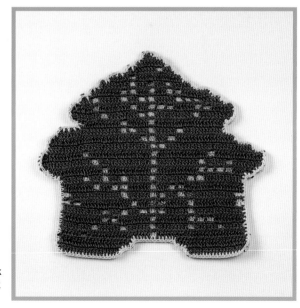

American Thread Company published *Star Potholders* in 1947. Cecilia Vanek was the designer of this maple leaf pot holder found on page 8. $15-18

Chapter Five

Yellow

With the termination of World War II America entered a period of prosperity; soldiers were reunited with families and the "baby boom" was underway. Housing construction was at a feverish pace, and each new home had a kitchen that required appliances, cabinetry, and materials to prepare and store food as guided by the homemaker's personal touch.

The single most important color in the 1950s was yellow. Vintage print advertisements that so vividly reflect the past showcased yellow with red, yellow with gray, yellow with pink, yellow with black, yellow with turquoise, yellow with green, but always yellow. Oh so modern, plastic kitchenware became an integral part of domestic America. Yellow plastic accoutrements included canisters, refrigerator dishes, sifters, hand-held gadgets and tools, trashcans, soap dishes, dinnerware, and more. Steel manufacturers, who had experienced a financial boom during World War II, promoted all-steel kitchen cabinets available in a rainbow of colors including yellow. One can assume that yellow soft goods seen today reflect the palette of this decade and were most likely created in the fifties.

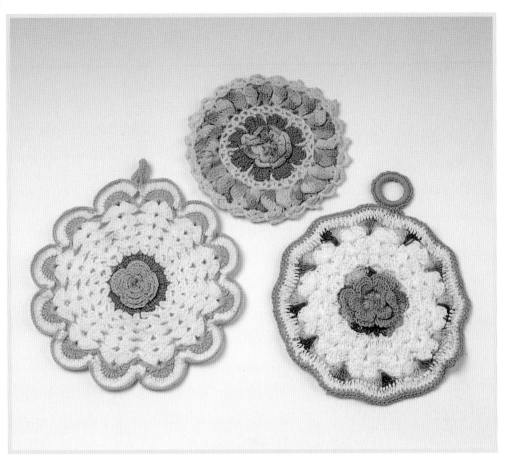

Rosettes grace the center of pieces contrasted with green. $8-10 each

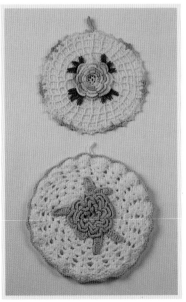

Both pot holders have rosettes and yellow trim, however the one on top is crocheted using variegated thread. $8-10 each

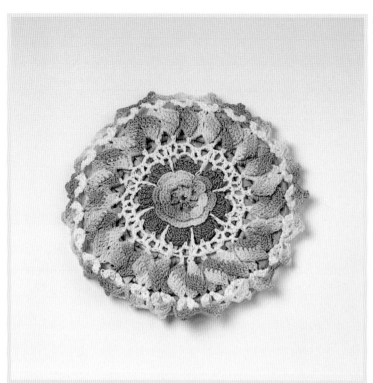

A floral rosette adds dimension and color to a hot pad mat. $8-10

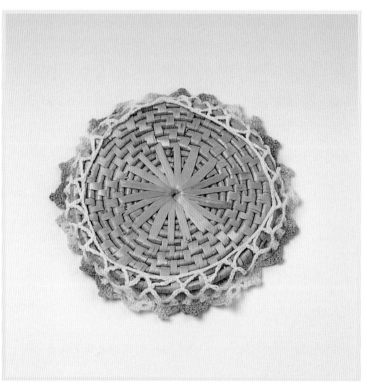

Shown is the underside of the mat in the previous picture. It was crocheted to fit a straw trivet affording the furniture protection while adding a burst of color.

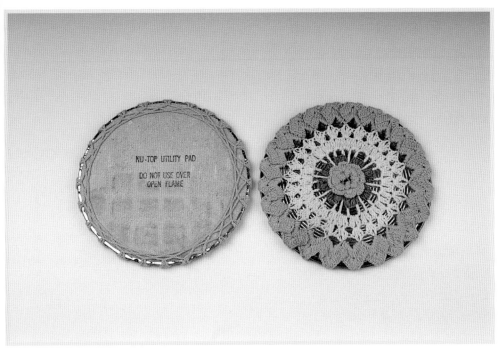

A pair of hot pad mats is crocheted over "Nu-Top Utility" pads. $8-10

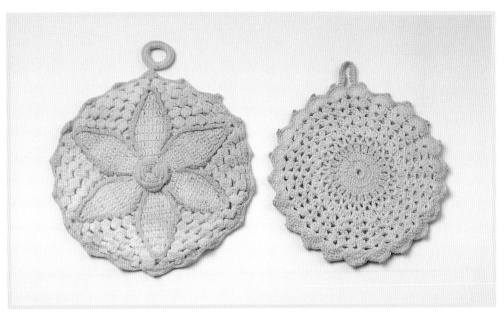

Crocheting a flower in the center of a pot holder, as shown on the left, is a common theme reminiscent of Pennsylvania Dutch hex signs. This one has the benefit of a rosette in the center. Notice that each of these examples was completed in yellow and beige rather than yellow and white. $8-10 each

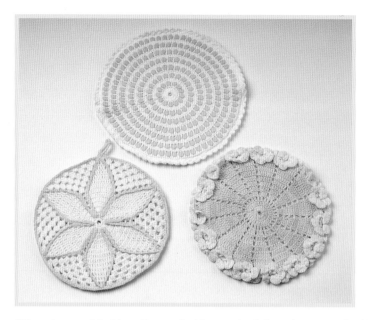

Although completed in yellow and white, each of these has a totally different design. The pot holder on top has yellow rickrack threaded through white crochet stitches. The pot holder on the bottom left is done in the hex sign motif. The pad on the bottom right is bordered with white blossoms. Often pieces with this type of dimensional rim were meant to be starched allowing the individual petals to be separated and freestanding. Some crochet books even provided starching directions. From page seven of *Gay and Gifty Crochet Ideas* (American Thread Company, c. 1951) come the following directions: "Dissolve 1/4 cup starch in 1/2 cup cold water. Boil about 1 cup of water, remove from flame, then slowly stir the starch mixture into boiling water stirring constantly. Place back on flame until it thickens. As soon as starch is cool enough to handle, dip [pot holders] and squeeze starch through them thoroughly. Wring out extra starch. The article should be wet with starch but there should be none in the space[s]. Place [on drying surface, adjust petals and shape] and let dry." $8-10 each

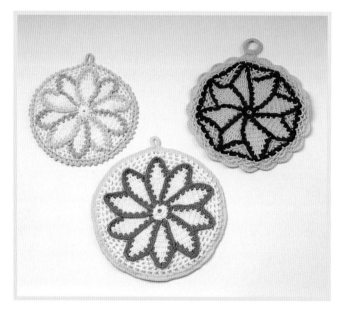

Here are three variations of the hex sign-like motif. Color choices, probably based on the kitchen for which each was created, greatly impact the look. $8-10 each

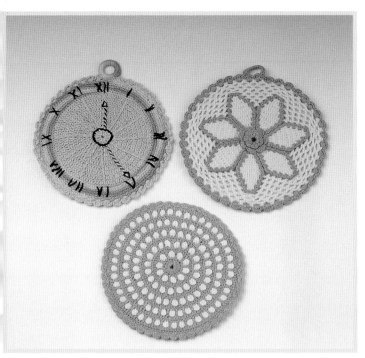

Pictured are three distinctly different pieces. The "clock" is a particularly whimsical design. The pot holder on the bottom was made with white rickrack threaded through yellow crochet stitches- just the opposite of one shown at the top of the previous page. The third offers a final example of the hex sign style. Clock, $15-18; other two pot holders, $8-10 each

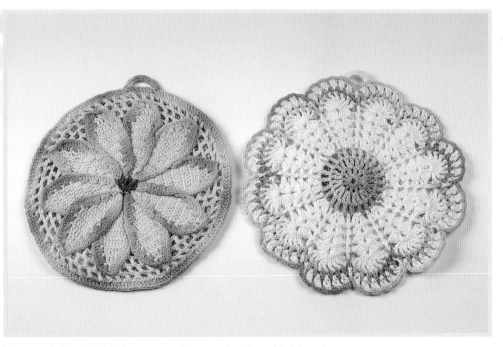

Variegated thread adds interest to these pot holders. $8-10 each

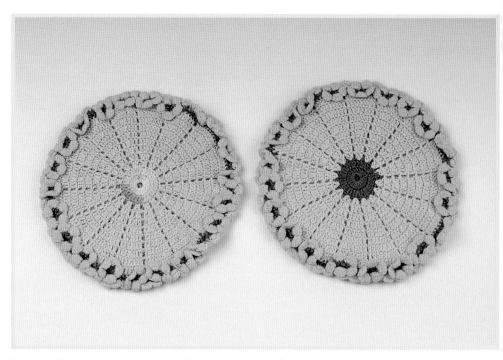

Two true fifties elements are exemplified: the use of yellow and the use of floral embellishment. $8-10 each

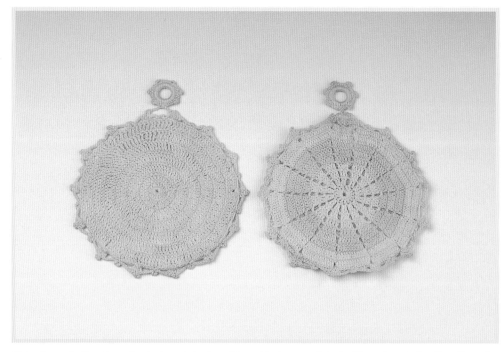

This shows both sides of a hot pad design. One side is completed with variegated yellow thread and the other side with a variegated yellow stripe and trim. $8-10 each

Double layers provide additional protection to the user of this pot holder. $8-10

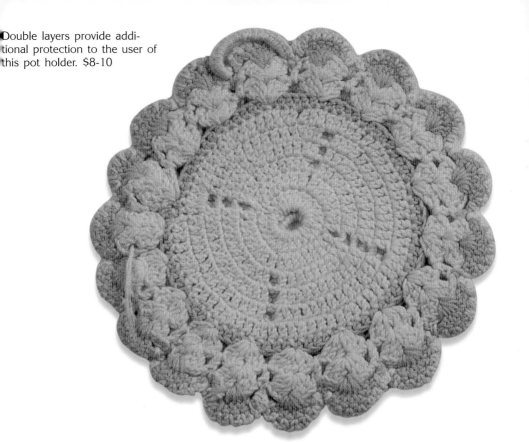

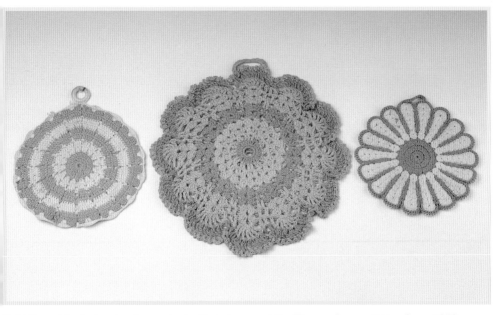

Gold thread looks lovely when paired with beige or white. The sunflower design from 1952, shown on the right, is still popular with collectors. $8-10 each

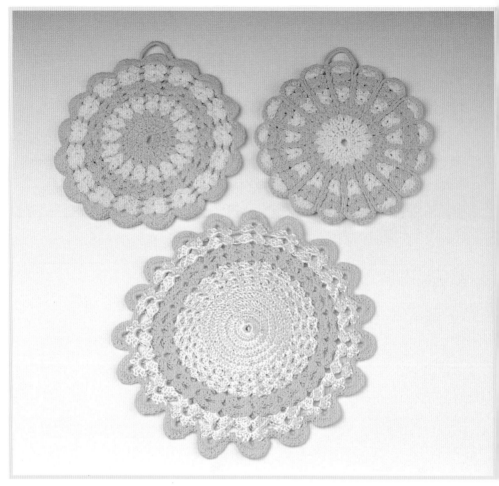

Except for the yellow trim on both, the pair on top offers a lovely example of positive-negative pot holders created to be displayed together. Where one is white the other is yellow. The hot pad mat at the bottom was crocheted with a glossy thread one rarely sees utilized in kitchen soft goods. $8-10 each

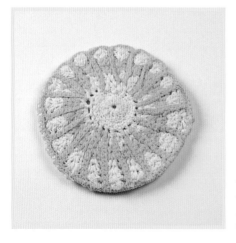

This pot holder measures a mere 3.5". It is very tightly crocheted making it stiff and thick, thus affording extra protection to the fingers it was created to protect. $8-10

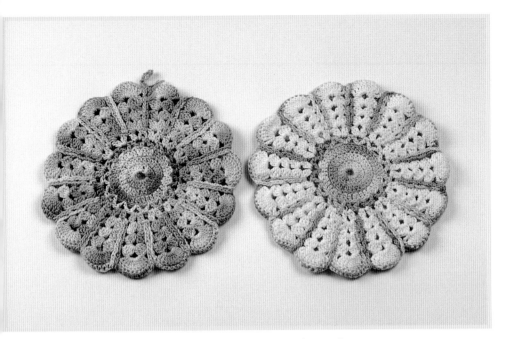

Here are more variations of the sunflower design. The use of a purple center may seem unexpected, however purple and violet were popular shades during the late fifties and early sixties. $8-10 each

Equally attractive when flipped over, shown is the reverse side of the two pot holders in the previous picture. $8-10 each

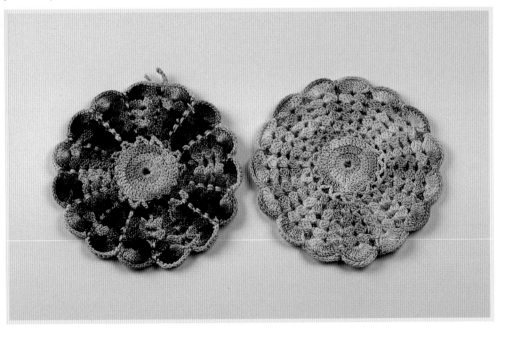

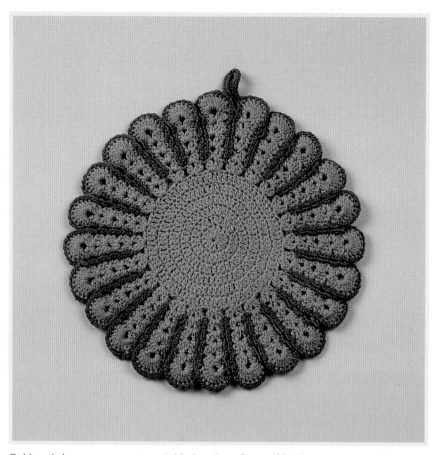

Gold and deep green create a richly hued sunflower. $8-10

Variegated thread adds interest to these pot holders. $8-10 each

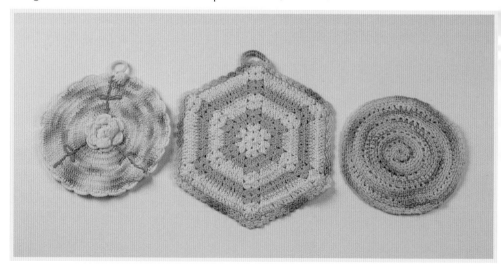

A relatively crude hot pad is paired with one having a pansy embellishment particularly popular in the early 1950s. $8-10 each

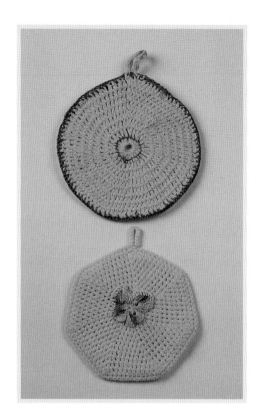

Yellow and white stripes bring a sense of cheerfulness to these pot holders. $8-10 each

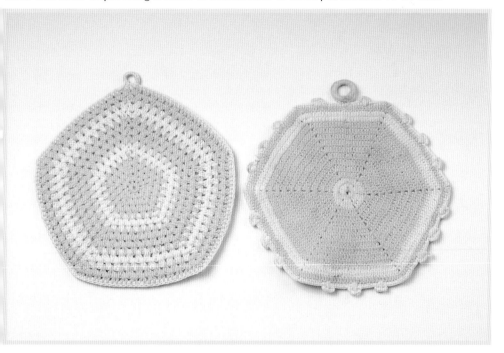

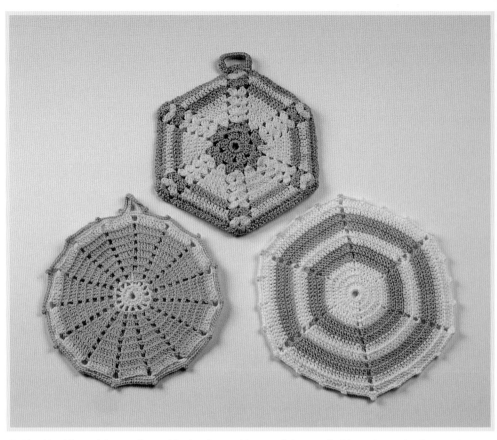

Gold with either white or almond lacks the perkiness of the pot holders shown in the previous picture. $8-10 each

This pot holder was made with plain white paired with yellow and pink variegated thread. The crocheted pieces are connected with variegated stitching in a manner similar to creating a patchwork quilt. $8-10

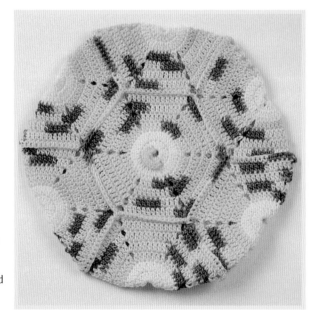

Two solid yellow pieces are bound together with blue thread. $8-10

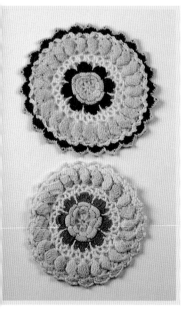

Although a victim of fading, the hot pad mat on the top is very similar to the hot pad mat on the bottom. $8-10 each

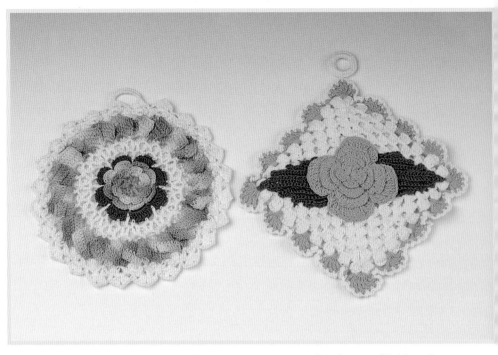

White, gold (plain and variegated) and green are common color choices. $8-10 each

Here are four variations on a theme: all are diamonds with rosettes. $8-10 each

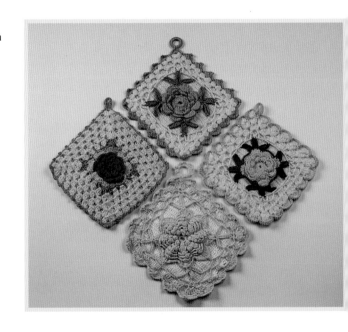

Variegated green and variegated yellow were used to create a double-layered pot holder. $8-10

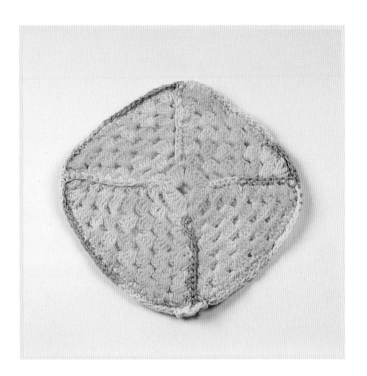

Yellow is paired with variegated purple in a less common combination. $8-10

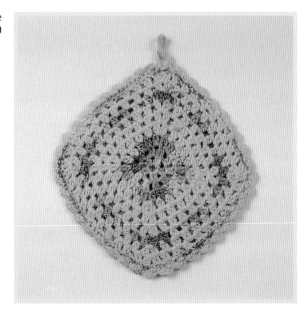

A huge rosette is the focal point of a beautifully executed pot holder. $8-10

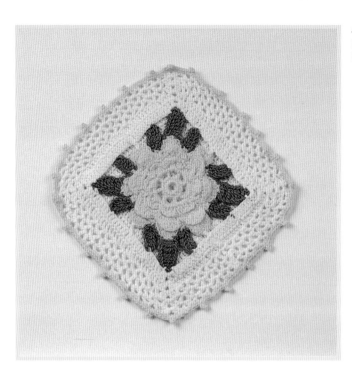

The diamond pot holder in the center is a style introduced in 1943, however, being yellow, most likely dates all three to the 1950s. $8-10 each

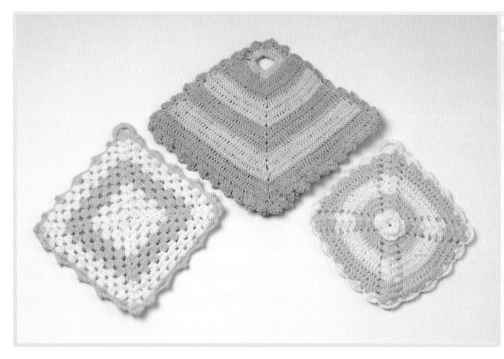

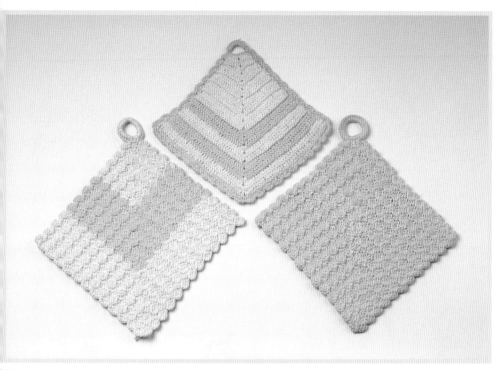

The bottom two diamonds are a positive-negative pair. $8-10 each

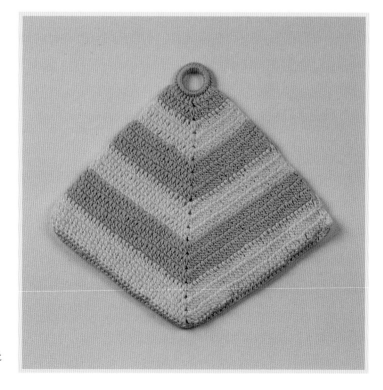

Wide gold and white stripes are very appealing in this diamond pot holder. $8-10

This pot holder was probably crocheted for a yellow and red kitchen. $8-10

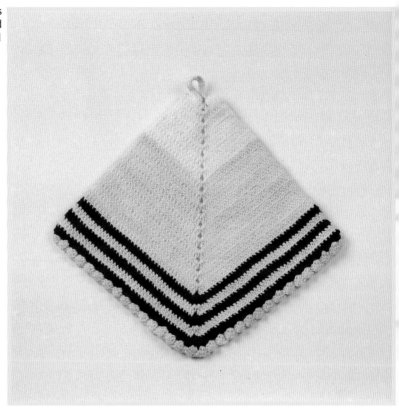

Simply turned on an angle, squares become diamonds. $8-10 each

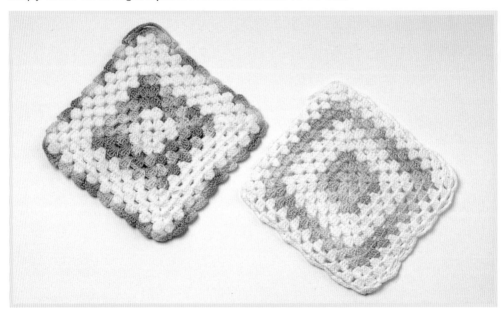

A virtual rainbow of colors creates a lively hot pad mat. $10-12

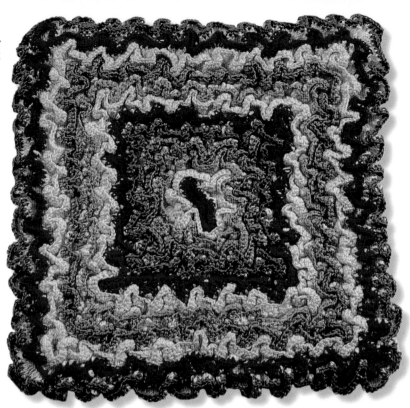

Quite thick, this hot pad mat would provide effective protection from hot casseroles. $8-10

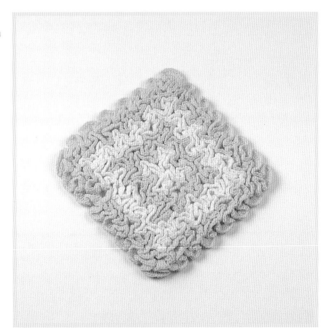

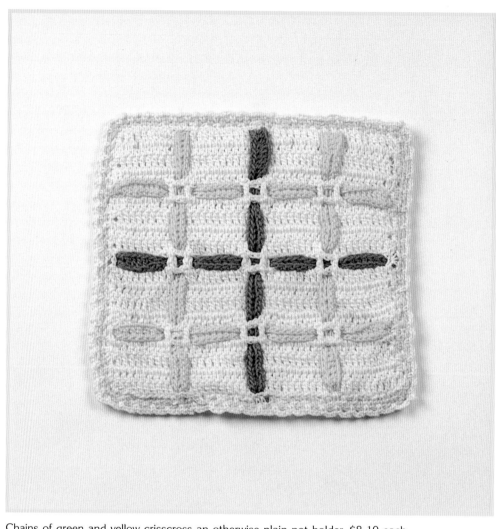

Chains of green and yellow crisscross an otherwise plain pot holder. $8-10 each

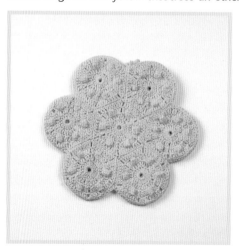

Although monochromatic, the stitches and shape make this a particularly interesting pot holder. $8-10 each

WE HOPE THAT YOU ENJOY ~~THIS BOOK~~ ...and that it will... ~~your~~
library. We would like to keep you informed about other publications from Schiffer Books.
Please return this card with your requests and comments.

Title of Book Purchased _____

☐ Purchased at: _____ ☐ received as a gift

Comments or ideas for books you would like to see us publish: _____

Your Name: _____

Address _____

City _____ State _____ Zip _____

E-mail Address _____

☐ Please send me a **free** Schiffer Antiques, Collectibles, Arts and Design Catalog
☐ Please send me a **free** Schiffer Woodcarving, Woodworking, and Crafts Catalog
☐ Please send me a **free** Schiffer Military, Aviation, and Automotive History Catalog
☐ Please send me a **free** Whitford Body, Mind, and Spirit Catalog
☐ Please send me information about new releases via email.
　　We don't share our mailing list with anyone

See our most current books on the web at **www.schifferbooks.com**

Contact us at: Phone: 610-593-1777; Fax: 610-593-2002; or E-mail: schifferbk@aol.com
SCHIFFER BOOKS ARE CURRENTLY AVAILABLE FROM YOUR BOOKSELLER

K: user\do\wp\basic\bouceback

SCHIFFER PUBLISHING LTD
4880 LOWER VALLEY ROAD
ATGLEN, PA 19310-9717 USA

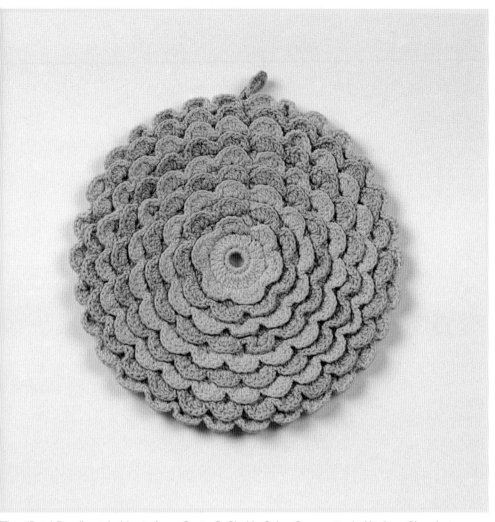

This "Petal Posy" pot holder is from Coats & Clark's Sales Corporation's *Kitchen Chrochet* published in 1964. $10-12

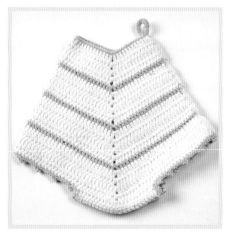

Introduced in 1947, dresses and panties are favorites today. $10-12

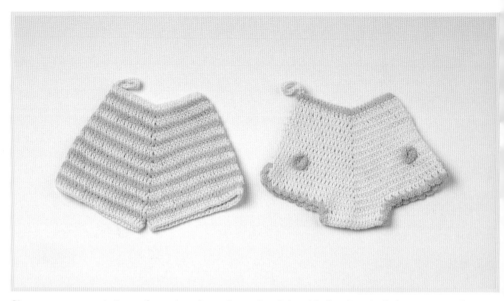

Shown are two variations of panties, the pair on the right with floral embellishments popular in the early fifties. $10-12 each

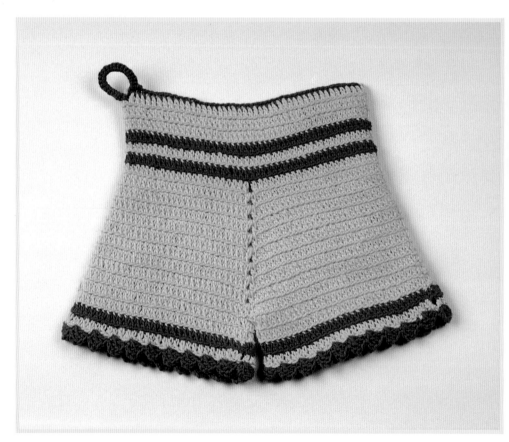

Royal blue trim looks bold on this pot holder. $10-12

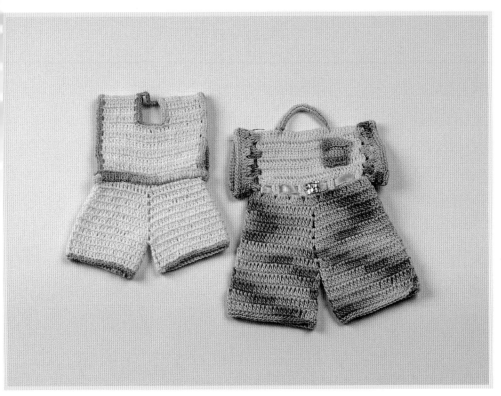

Variegated thread adds interest to this less common style. Note the "belt" on the hot pad on the left. $12-15 each

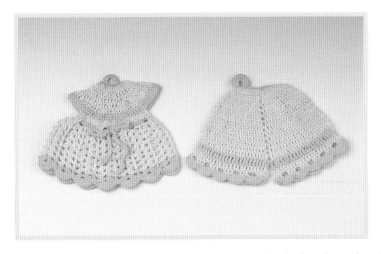

Matched dresses and panties are hard to find. Made as a set to be displayed together, they deserve to remain together. Dress, $12-15; panties, $10-12

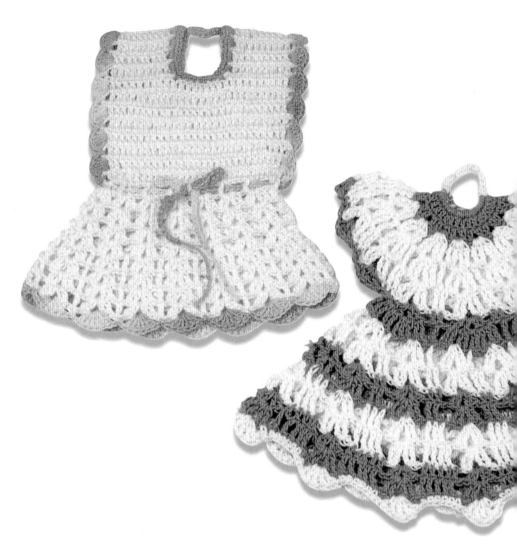

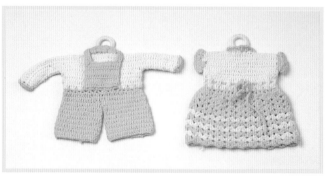

Another matched set, the "boy's outfit" is an extremely rare design perhaps styled from doll clothing. $12-15 each

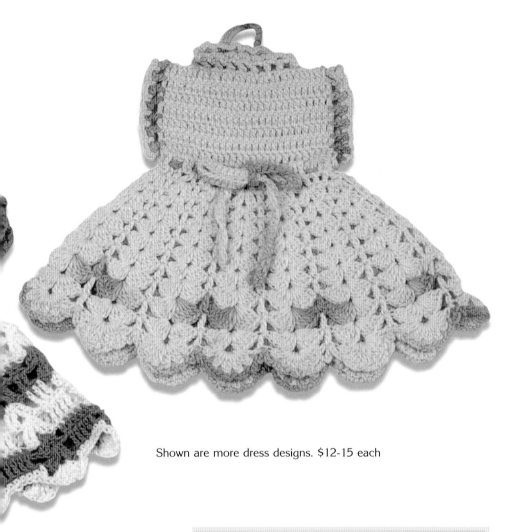

Shown are more dress designs. $12-15 each

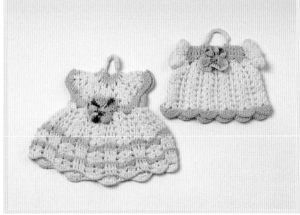

Pansies embellish two similar dresses.
$12-15 each

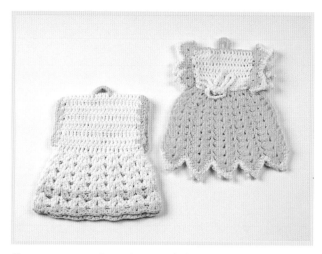

Shown are more dress designs. $12-15 each

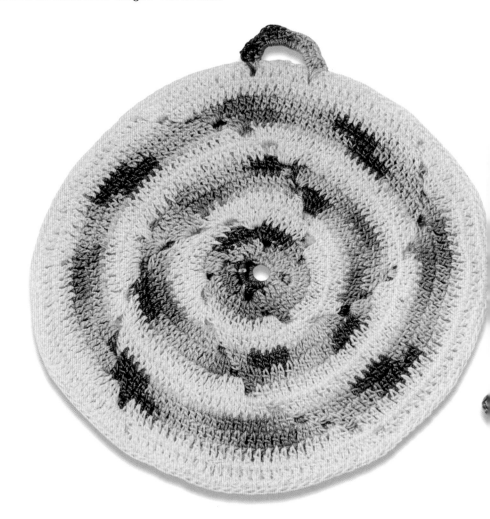

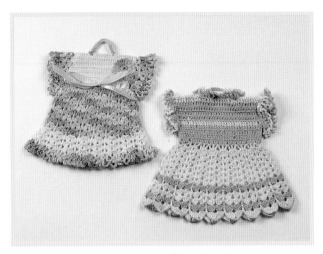

Shown are more dress designs. $12-15 each

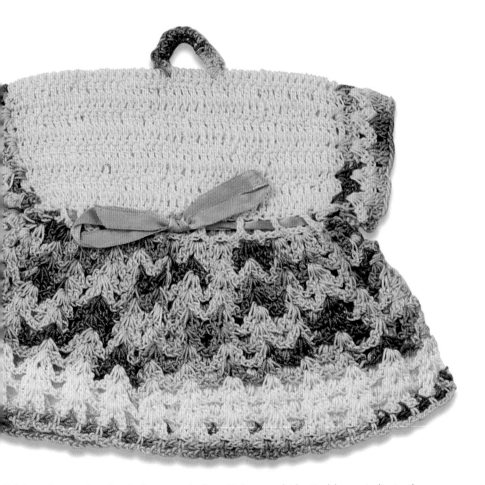

Bright yellow and variegated green, similar stitches, and identical loops indicate the same person created these. Circle, $6-8; dress, $12-15

An extremely realistic corn pot holder was created using the directions found in *Gay and Gifty Crochet Ideas,* American Thread Company's 1951 book. $15-18

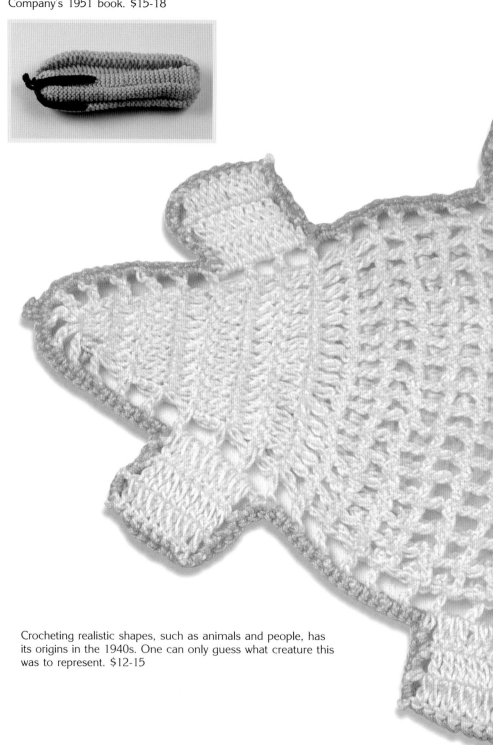

Crocheting realistic shapes, such as animals and people, has its origins in the 1940s. One can only guess what creature this was to represent. $12-15

Shown are two sides of the same design. The "front" is a piece of fruit crocheted with a simple stitch, and the reverse is completed with variegated thread crocheted in a more complicated stitches. $12-15 each

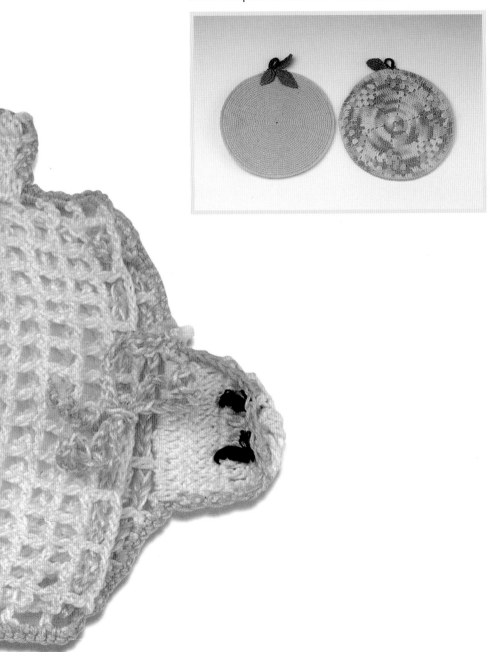

Chapter Six

Pink

The popularity of pink as a kitchen color was a short-lived event in the early 1950s. PYREX created a series of refrigerator dishes and mixing bowls in pink, and Fire-King launched Pink Swirl dinnerware. Androck and other manufacturers offered kitchen gadgets with pink handles that were often striped in black, tan, or gray. Even steel kitchen cabinets and linoleum floors were available in pink, but compared with the other colors featured in this book, pink experienced the shortest period of consumer acceptance.

Perhaps the relatively poor performance of pink in the marketplace was a backlash effect of pink Depression Glass. By the 1940s, pink glassware was considered old-fashioned and outdated so manufacturers began to produce clear glass. Just few years later, in the 1950s, pink was again being offered albeit in different forms. One can surmise that too many homemakers were reminded of "that old pink glass" and didn't redecorate in pink. Today we are left with a very limited selection of collectible pink kitchenware and a large contingency of collectors favoring this color.

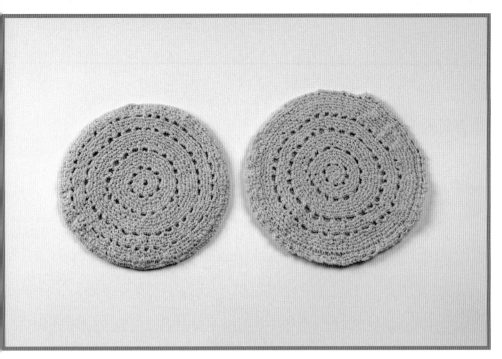

Both of these round pot holders are double thickness for added protection when handling hot casseroles and pots. $6-8 each

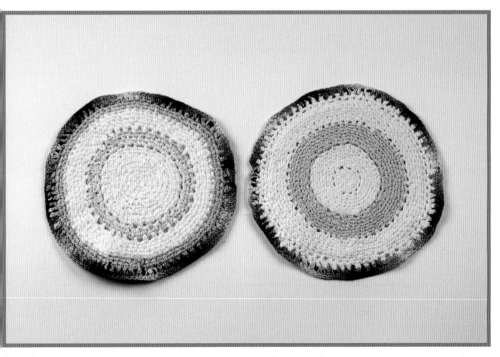

Use of colors and stitches reveal the same person made these. Purple may seem unexpected, but it enjoyed a period of popularity in the late 1950s and early 1960s. $6-8 each

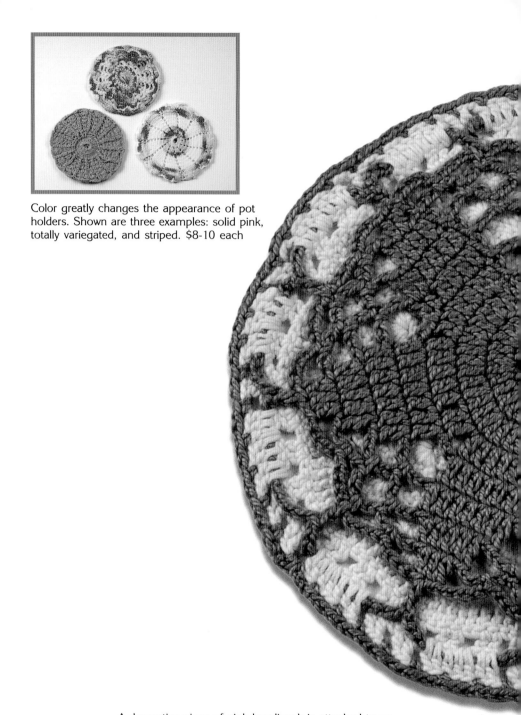

Color greatly changes the appearance of pot holders. Shown are three examples: solid pink, totally variegated, and striped. $8-10 each

A decorative piece of pink handiwork is attached to an ecru bottom. $8-10

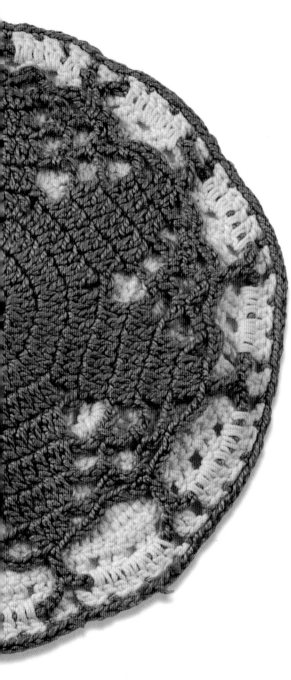

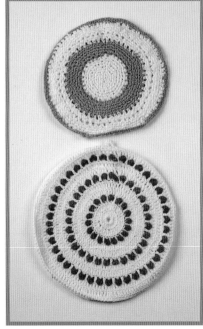

The bottom pot holder has pink rickrack threaded through white crochet stitches. Top circle, $6-8; bottom (with rickrack), $8-10

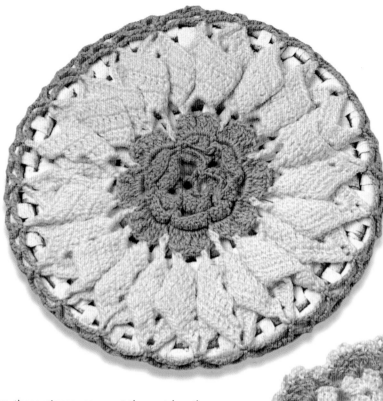

Almost peach in color, these pieces represent three styles: the upper left is stretched over a straw trivet, the upper right has white rickrack threaded through the stitches, and the bottom features the ever-popular rosette. $8-10 each

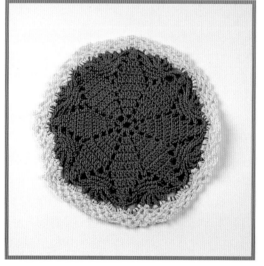

Off white trims a rose-colored pot holder. $8-10

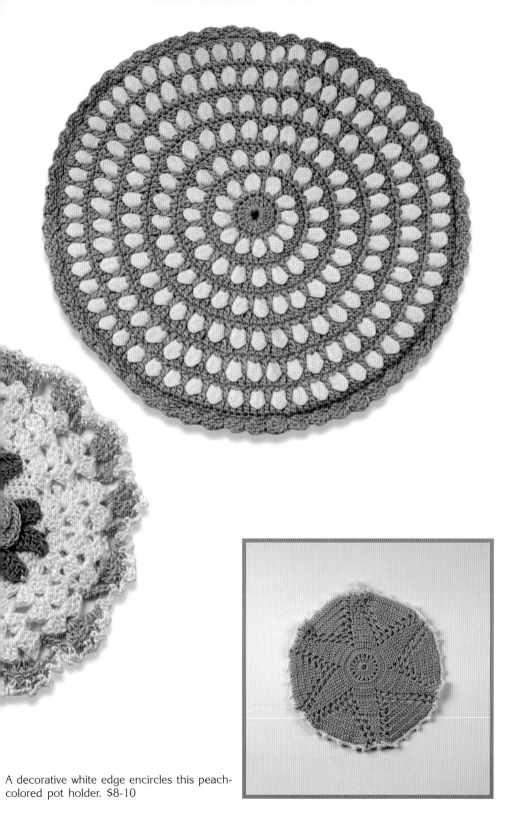

A decorative white edge encircles this peach-colored pot holder. $8-10

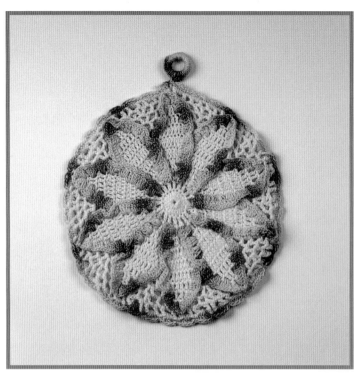

Details of a flower are crocheted in variegated pink thread. $8-10

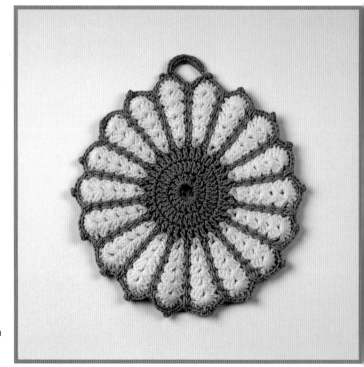

A simple sunflower design
from 1952 is still popular
with collectors. $8-10

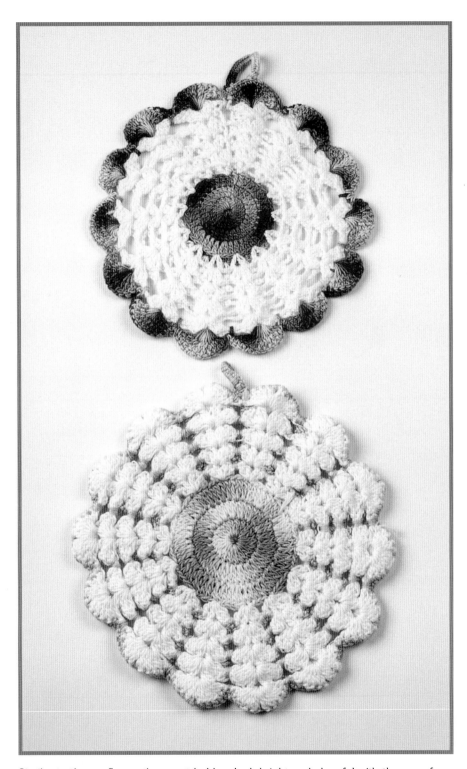

Similar to the sunflower, these pot holders look bright and cheerful with the use of white thread. $8-10 each

Gray and pink were promoted as go-along colors. The interesting twist to this pot holder is the variegated thread that includes pink and green. By using this multi-colored thread in both the center and outer edge, a comfortable balance has been achieved. $8-10

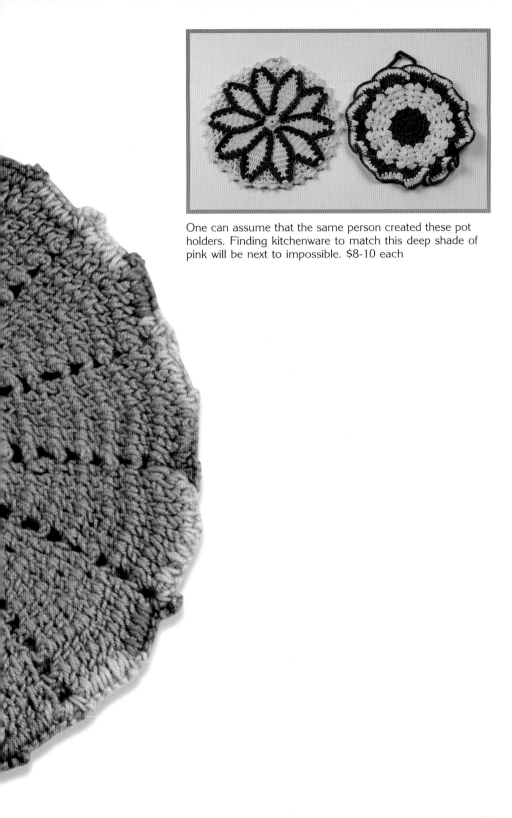

One can assume that the same person created these pot holders. Finding kitchenware to match this deep shade of pink will be next to impossible. $8-10 each

Shown are two sides
of the same design.
$8-10 each

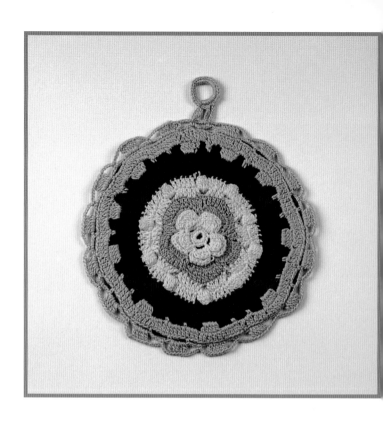

Bright bands of color surround a yellow rosette. $8-10

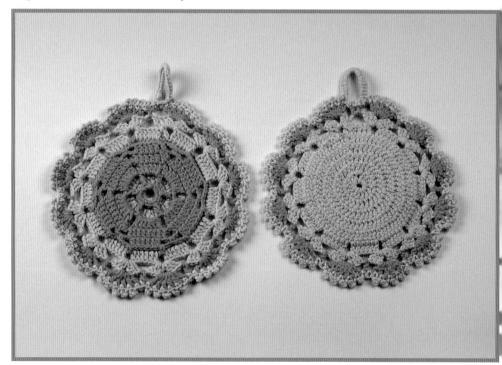

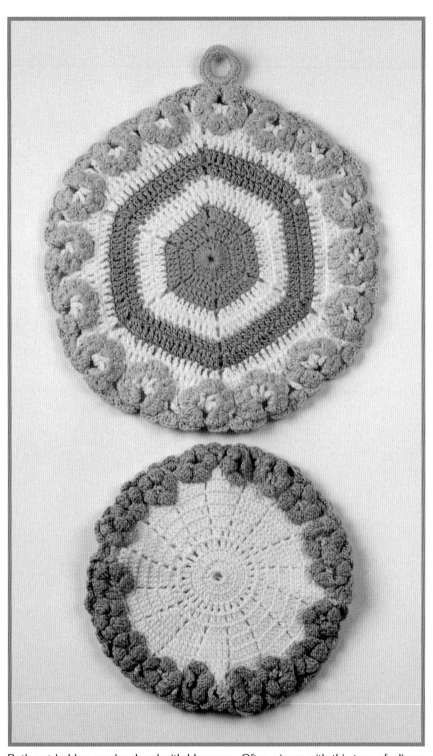

Both pot holders are bordered with blossoms. Often pieces with this type of dimensional rim were meant to be starched allowing the individual petals to be separated and free-standing. $8-10

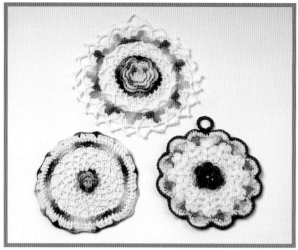

Despite all three pot holders having rosettes, they are distinctly unique. $8-10 each

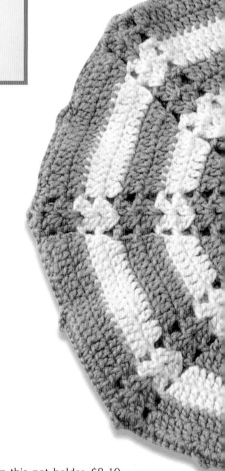

Pink and white stripes encircle and brighten this pot holder. $8-10

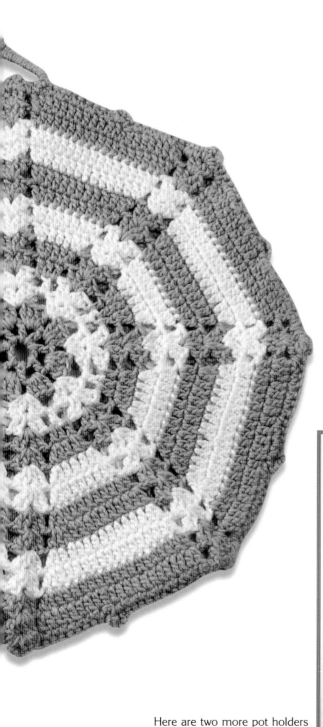

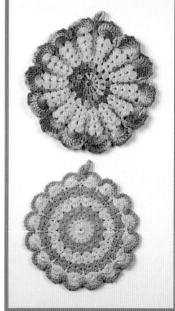

Here are two more pot holders reminiscent of the sunflower.
$8-10 each

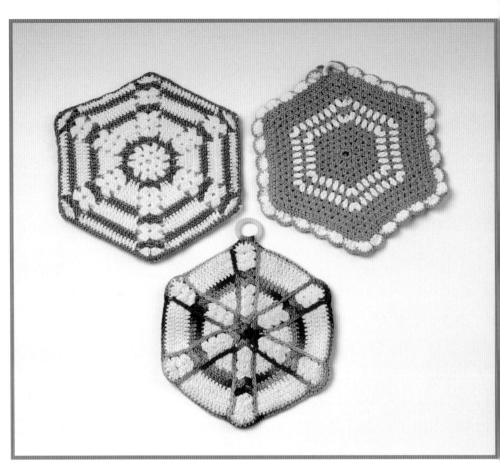

These three pot holders share the same shape, colors, and size, but the similarities end here. Choice of stitches and threads create a wonderful array of finished work. $8-10 each

White and variegated pink stripes create a simple yet interesting pot holder. $8-10

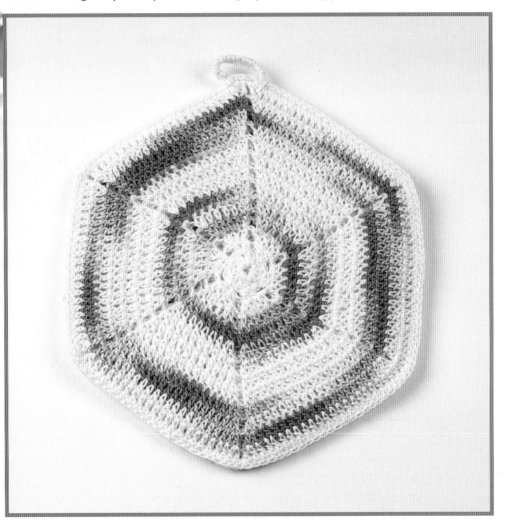

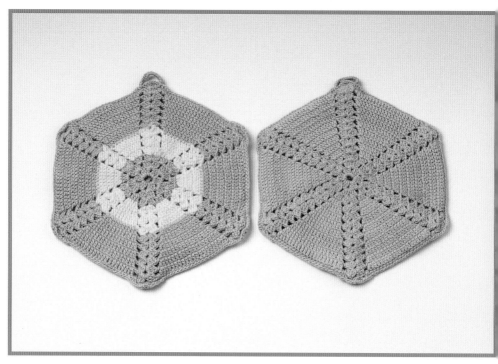

Shown are two sides of the same design with a pink that is almost peach in color. $8-10 each

Broad pink and turquoise stripes reflect true fifties colors. $8-10

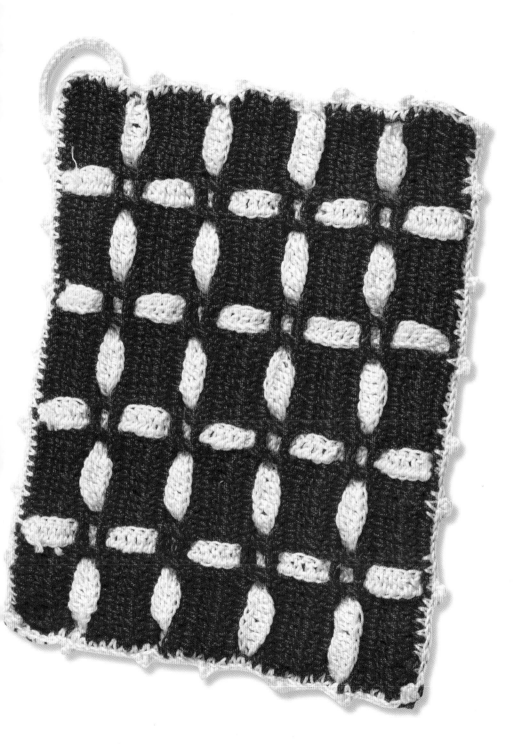

Thin bands crocheted in white are woven to create the
illusion of a checkerboard. $8-10

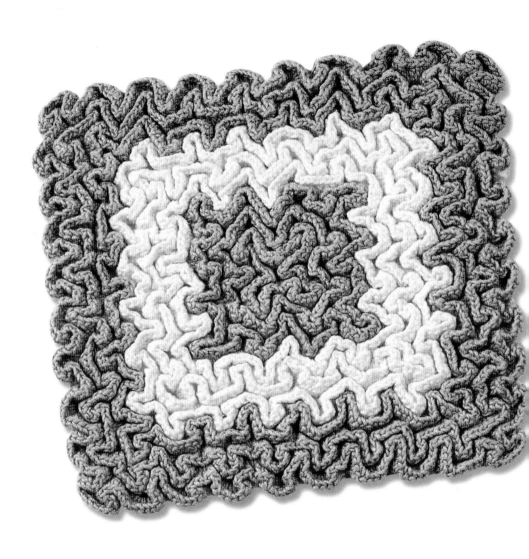

A complicated stitch is balanced with simple color choices on a hot pad mat that is thick and protective. $10-12

Pot holders with rosettes are among the favorites with today's collectors. $8-10

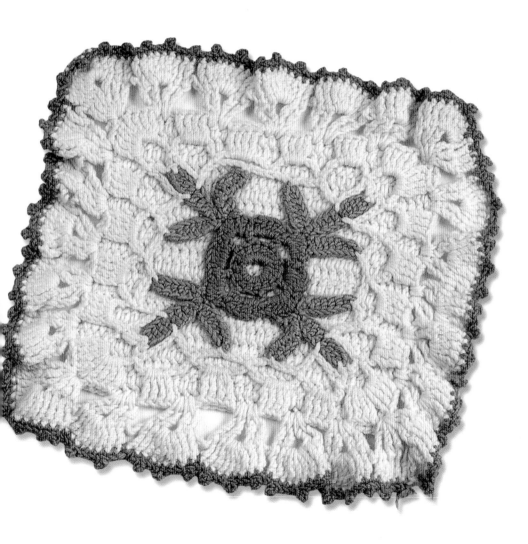

Ribbon is threaded through two crocheted pieces that crisscross a square base. Highly decorative with bows and a rosette, this pot holder seems too lovely to use. $10-12

Quick Tricks in Crochet (The Spool Cotton Company, c. 1950) provided directions for a "Platter Mat" which was two enlarged Hot Plate Mats worked together into one piece without an asbestos mat. Crochet books from the 1950s often offered directions for creating matched sets that included napkin holders and even aprons. Shown are a matching pot holder and "platter mat." Hot pad (top), $8-10; platter mat (bottom), $12-15

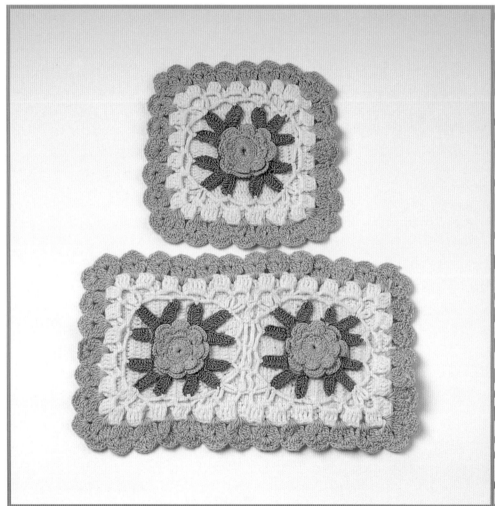

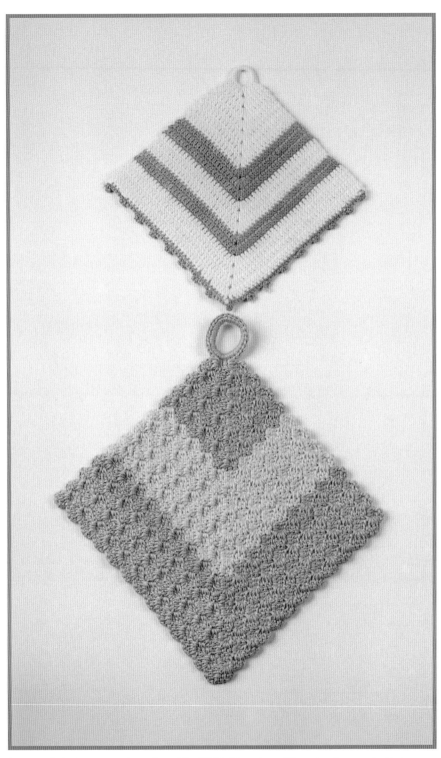

Diamond designs were introduced in 1943. By using different colors and stitches a huge assortment of pot holders can be created. $8-10 each

Diamond designs were introduced in 1943. By using different colors and stitches a huge assortment of pot holders can be created. $8-10 each

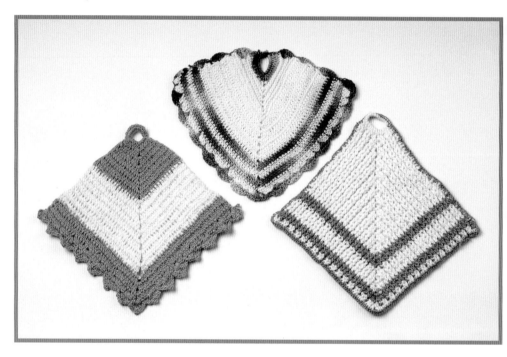

Turning a square on an angle creates
a diamond-shaped pot holder that
was lined with pink felt for additional
heat protection. $8-10

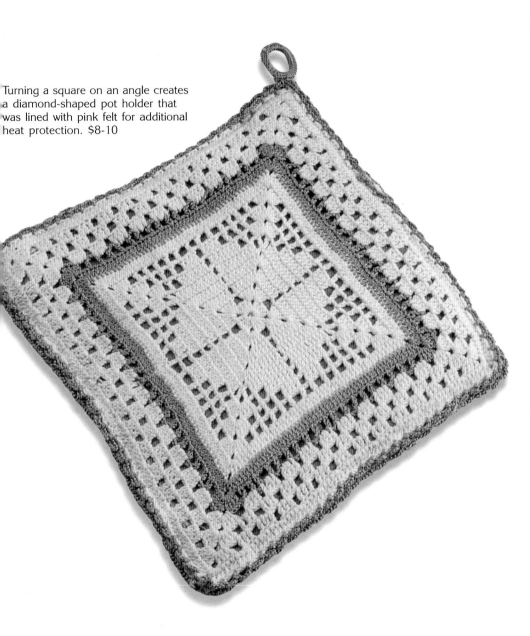

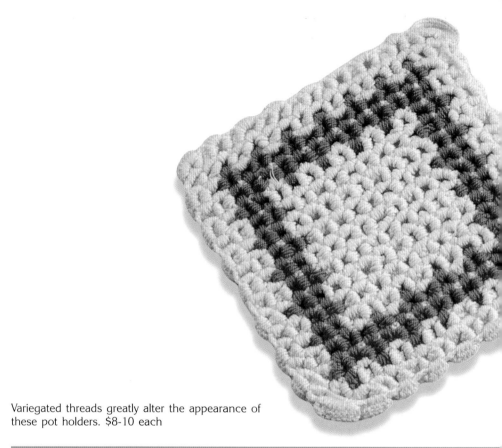

Variegated threads greatly alter the appearance of these pot holders. $8-10 each

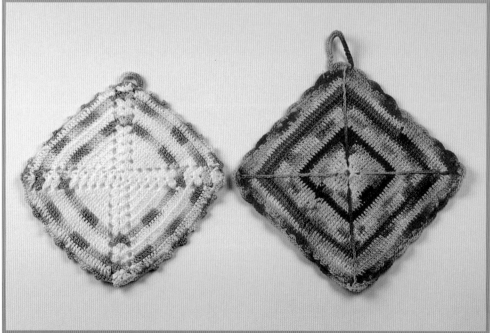

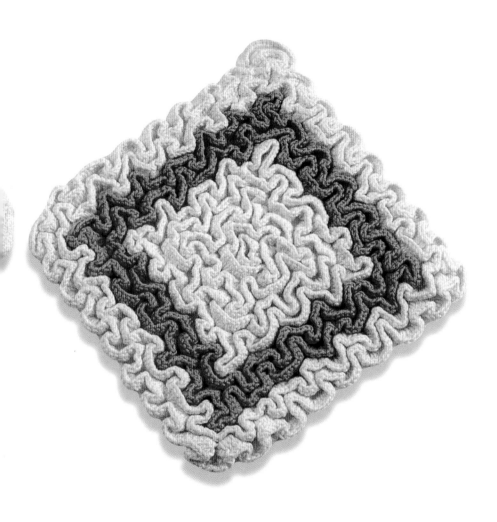

Shown are two sides of the same design. $10-12 each

Bands of pink and white create a simple, yet pleasing piece. $8-10

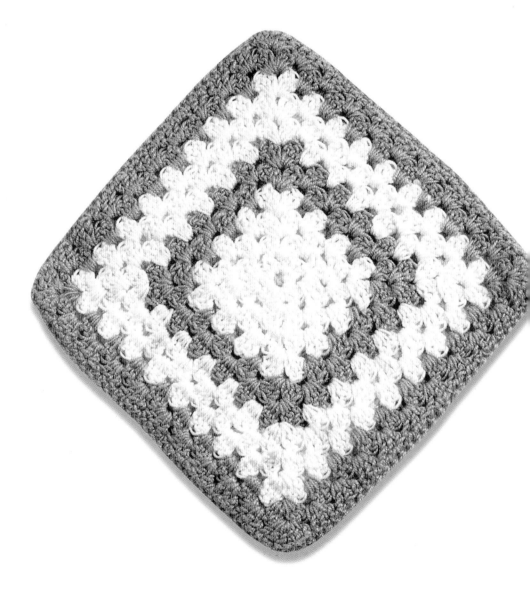

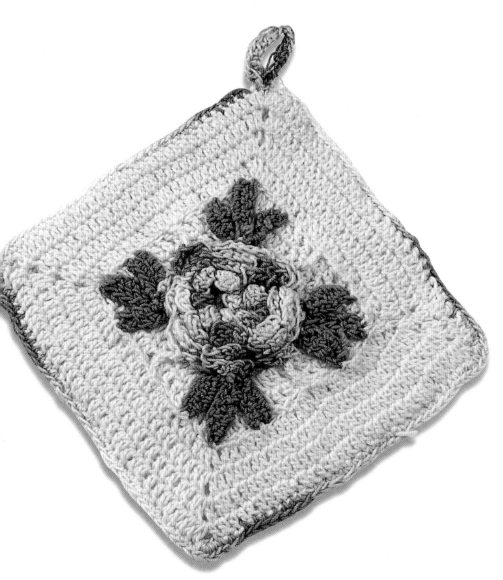

The fifties color of pink is shown with a fifties rosette, a favorite with today's collectors. $8-10

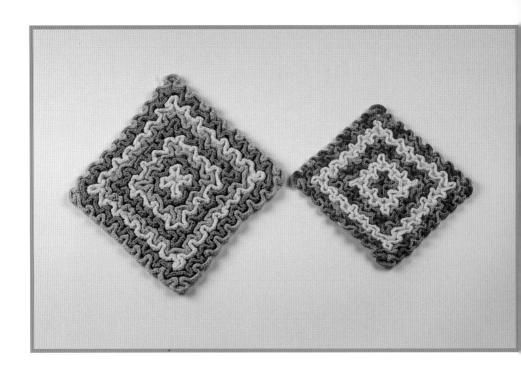

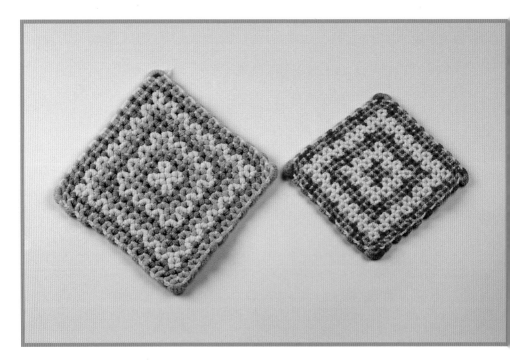

Shown are both sides of the same design.$10-12 each

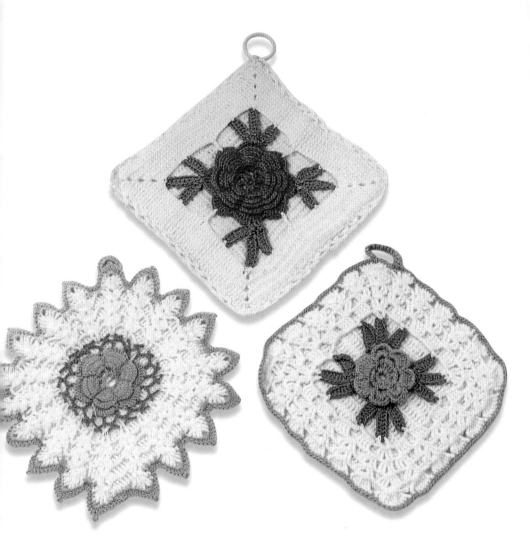

Three pink and white pot holders with pink rosettes are similar yet unique. $8-10 each

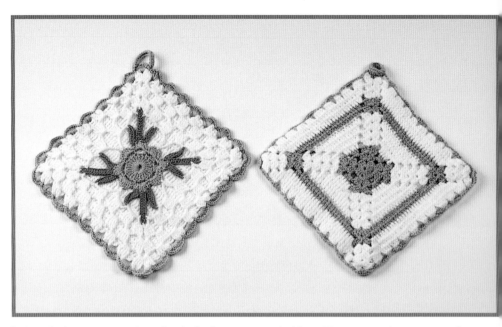

Pink and white create a clean, bright look on two pot holders. There is no dimension to the rosette on the left. $8-10 each

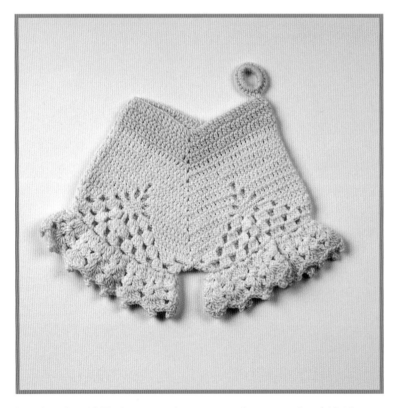

Introduced in 1947, dresses and panties are favorites today. $10-12

Crocheted baskets were created to hold one, two, or three pot holders in coordinating colors and stitches. Diamond and Circle (top), $8-10 each; basket, $10-12

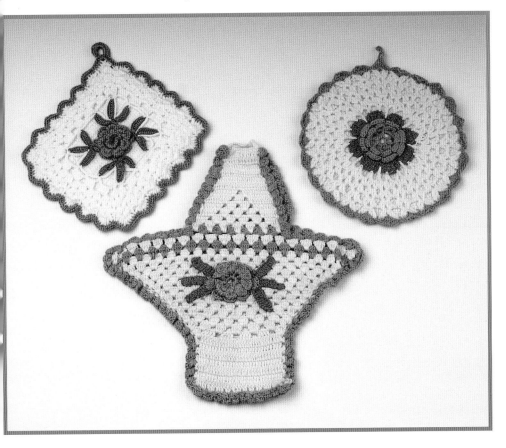

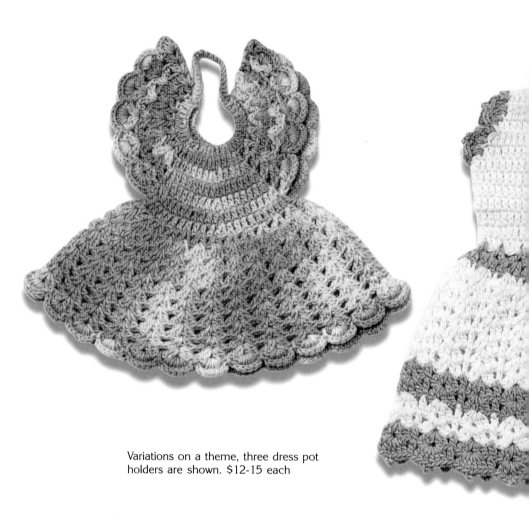

Variations on a theme, three dress pot holders are shown. $12-15 each

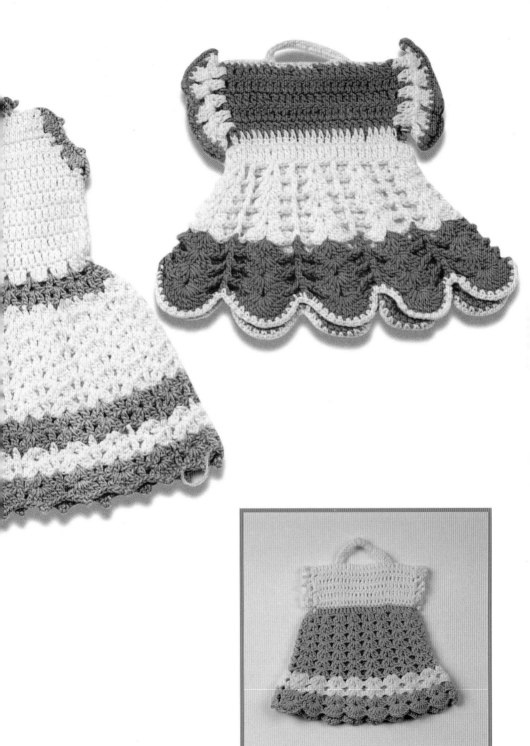

This dress is simple in design and execution.
$12-15

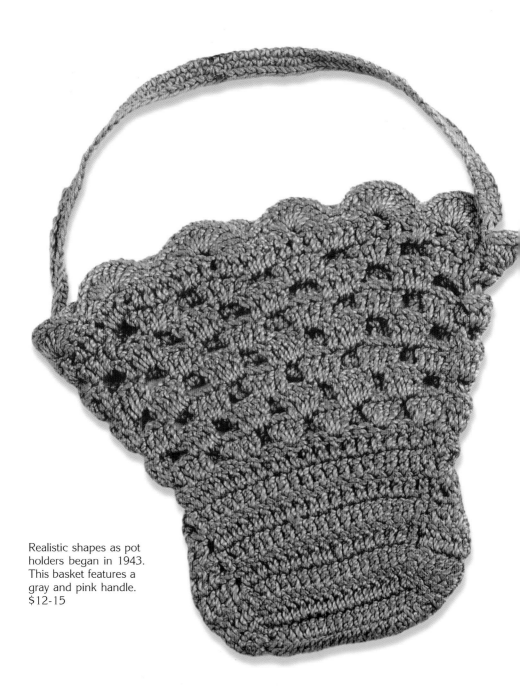

Realistic shapes as pot holders began in 1943. This basket features a gray and pink handle. $12-15

American Thread Company, Inc. published *Star Pot Holders* in 1944. This recipe booklet with pot holder instructions included "Eggs Foo Young" and two hot pads with embroidered Asian faces. One cannot be sure if the Asian-like faces on this pair is by mistake or by design. $12-15 each

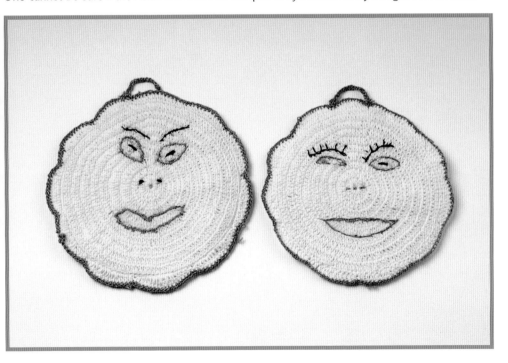

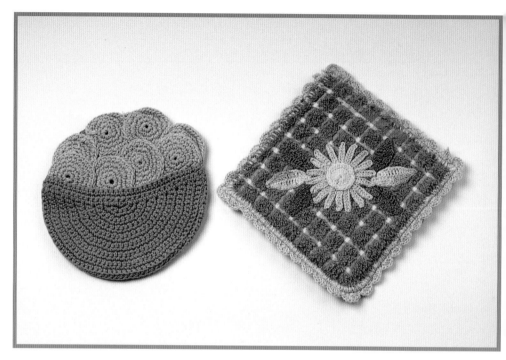

Brown and pink combine wonderfully when crocheted together in these pot holders. On the left is a bowl of ice cream. The pot holder on the right incorporated a square of terry cloth fabric. $15-18 each

Introduced in 1953 as a way to eliminate the use of asbestos mats, bottle cap hot pad mats are very popular today. This bunch of grapes utilizes twenty-nine bottle caps. $12-15

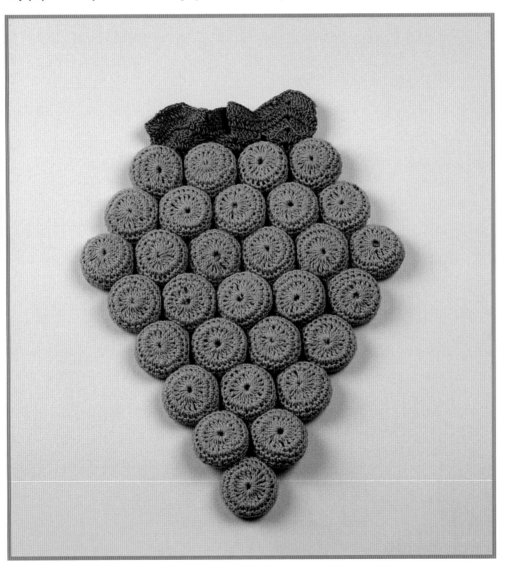

Chapter Seven

Miscellaneous Colors

Most purchases of kitchen collectibles are made for one of two reasons. First the item has to have appeal. In some silent way it shouts to the shopper, "Adopt me! Take me home! You know you love me! Think how wonderful I will look in your house!" That leads us to the second reason a purchase is made; the item is perceived to be a good match for a particular kitchen. This may be a theme match, such as someone is decorating with vegetables and a piece with produce "just works." More likely, the match is color-based, as a palette is selected and the decoration begins. Pink and green, red and white, yellow and jade-ite, turquoise and black; whatever the scheme only items that have the right color value are considered. The arrangement of these chapters is very sensitive to this fact. However, not all interesting pieces can be placed into categories as basic as red, blue, or green. For these unique treasures, here is Chapter Seven.

The pieces that follow may not belong in your kitchen and in fact may have difficulty matching most kitchens, but they are worthy of your consideration. Someone took time and love to create them and decades later they remain for our appreciation. Remember, purple is great at Easter, and besides, if you like it, who cares?!

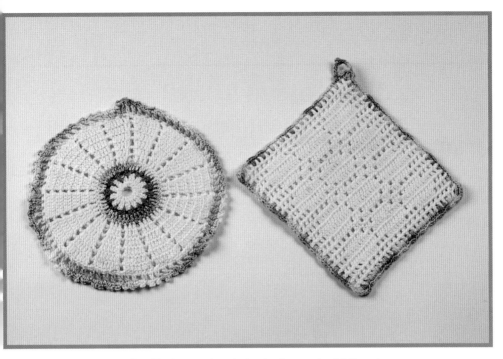

Pastel variegated threads border diamond and circular hot pads. $6-8 each

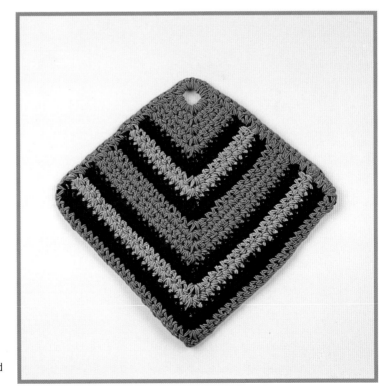

Bold stripes of turquoise, pink, and black reflect fifties colors in a diamond design that originated in 1943. $8-10

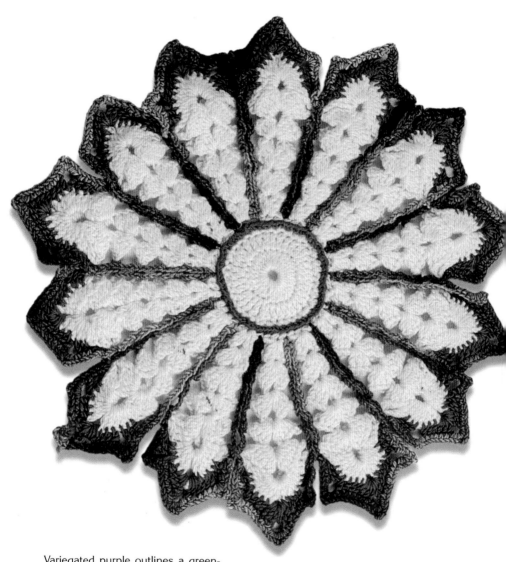

Variegated purple outlines a green-tipped pot holder. $8-10

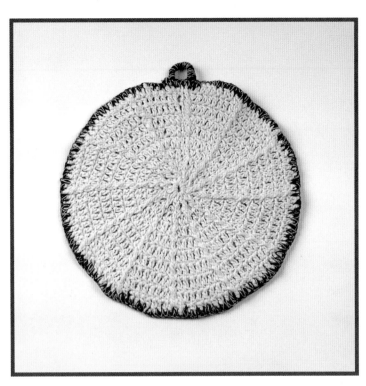

Burnt orange and gold trims the edge of a round pot holder. $6-8

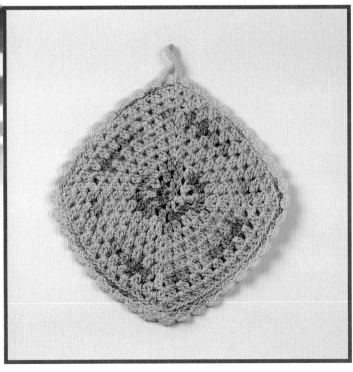

Largely mint green, this has a yellow trim with blue and pink variegated highlights. $8-10

Similar to the sunflower
motif, this white pot
holder is edged in lilac
variegated thread. $8-10

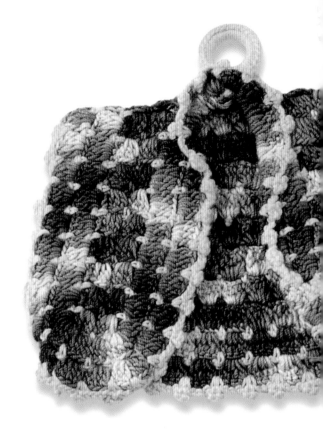

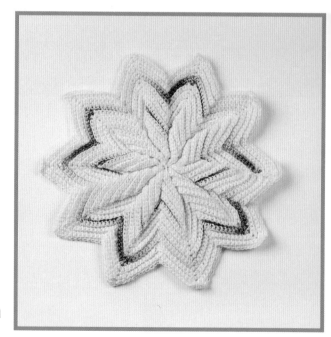

A dimensional flower pot holder
features two stripes of yellow and
purple variegated thread. $8-10

ntroduced in 1947, dresses and panties are favorites today.
Crocheted in a deep purple variegated thread and trimmed in
yellow, these pieces are a matched set. $12-15 each

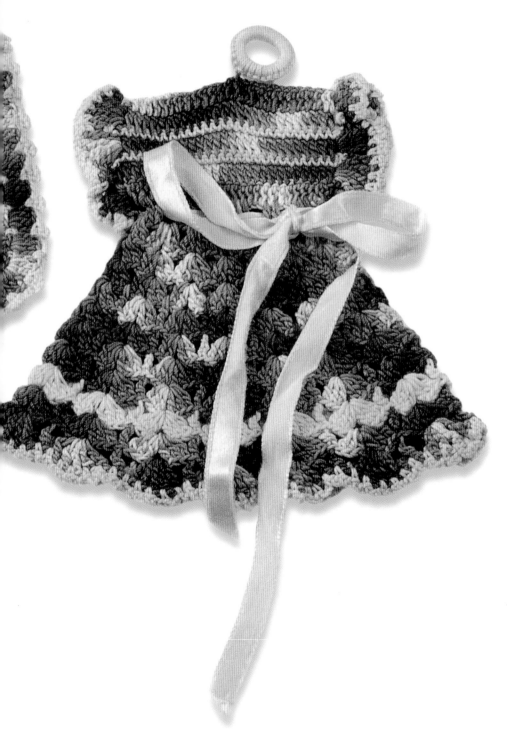

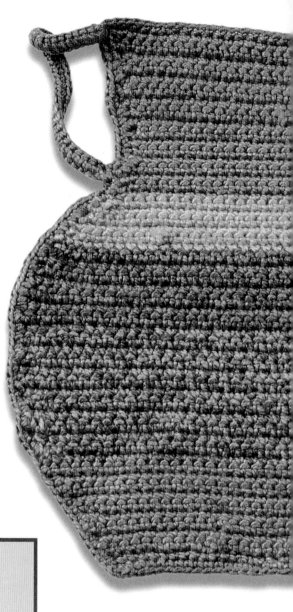

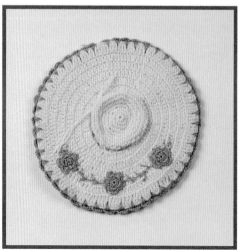

Reminiscent of an Easter bonnet, this pot holder is truly unique. Note the floral embellishments, a detail dating this to no earlier that 1950. $15-18

Realistically shaped pot holders are difficult to find. This cream pitcher may have had a matching sugar bowl. The uneven bands of stripes in mismatched colors make one wonder if the creator was attempting to utilize thread leftover from previous projects. $10-12 as shown, higher value with more appealing colors

This happy couple is here to say farewell! $18-20 each

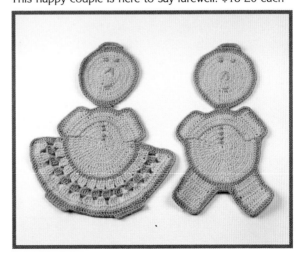

Bibliography

American Thread Company. *Gay and Gifty Crochet Ideas*, 1951.

American Thread Company. *Pt Holders Hot Plate Covers Swedish Embroidery*, 1953.

American Thread Company. *Hot Plate Mats*, 1950.

American Thread Company. *New Table Designs*, 1946.

American Thread Company. *Star Pot Holders*, 1944.

American Thread Company. *Star Pot Holders*, 1947.

Coats & Clark Incorporated. *Kitchen Crochet*, 1964.

Coats & Clark Incorporated. *New Quick Tricks to Crochet and Knit*, 1954.

Coats & Clark Incorporated. *Table Magic*, 1953.

Lily Mills Company. *Crocheted & Knitted Kitchen Craft*, 1950.

The Spool Cotton Company. *Pot Holders*, 1943.

The Spool Cotton Company. *Pot Holders*, 1945.

The Spool Cotton Company. *Pot Holders for Kitchen Pick-Me-Ups*, 1952.

The Spool Cotton Company. *Pot Holders to the Rescue*, 1941.

The Spool Cotton Company. *Quick Tricks in Crochet*, 1950.